THE SELF PORTRAIT

A MODERN VIEW

THE SELF PORTRAIT

A MODERN VIEW

SEAN KELLY

EDWARD LUCIE-SMITH

SAREMA PRESS, LONDON

First published 1987
Sarema Press (Publishers) Limited
KGM House, 26–34 Rothschild Street, London SE27 0HQ

Text © Edward Lucie-Smith 1987
Introduction © Sean Kelly 1987
Photographs of the works and Compilation Copyright © Sarema Press (Publishers) Limited, 1987

The Self-Portrait : A Modern View
 1. Self-portraits, British
 2. Portrait painting—20th century—Great Britain
 I. Lucie-Smith, Edward II. Kelly, Sean
 757′0941 ND1314.6

ISBN 1 870758 00 5

Designed by Tim Harvey
Photographs of the works by Prudence Cuming Associates
Set in Apollo by BAS Printers Limited, Over Wallop, Hampshire
Printed in England by Jolly and Barber, Rugby

A Rookledge International Publication

PUBLISHER'S ACKNOWLEDGEMENTS

The Publisher, Gordon Rookledge would like to
thank Edward Lucie-Smith for introducing Sarema
Press to Sean Kelly of Artsite and setting in motion
the chain of events that led to this book being
published. He would also like to thank Sean Kelly;
Tim Harvey, the designer; Melissa Denny, Editor,
and Sarah Rookledge, Assistant Editor, for all their
help in producing this book; Marnix Zettler of ISTD
for arranging the paper sponsorship, and the staff
of Artsite for their help and co-operation.

August 1987

 This book is printed on Parilux Matt 135 gsm
which was kindly supplied by Société Job in France

SEAN KELLY

The genesis of *The Self-Portrait: A Modern View* arose from a conversation with the artist Harry Holland, who observed that the possibilities inherent in a number of contemporary British artists being invited to make a self-portrait would be fascinating – and would constitute an outstanding exhibition. I was in agreement that such a show would indeed present an opportunity to assemble a collection of work which would demonstrate the strength and diversity of representational painting and sculpture currently produced in Great Britain, and undertook to organise the exhibition.

At this stage Edward Lucie-Smith and Gordon Rookledge of Sarema Press became enthusiastic participants in the creation of *The Self-Portrait: A Modern View*. We knew that the success of the project would be largely dependant upon attracting the involvement of a representative cross-section of artists. It was decided that the only restriction to be placed upon work was one of size: two-dimensional pieces should be no larger than 92 cm × 72 cm, classic portrait scale; sculpture should be life-size or smaller. Ted and I compiled a list of 60 artists and sent out the letters inviting participation. The response was overwhelmingly positive: within ten days, 46 of the artists had confirmed their involvement and we knew that an outstanding exhibition was underway.

The self-portrait has consistently been one of the enduring traditions in the history of western art, and a medium through which a number of artists have produced some of their most revealing work. Rembrandt's recurrent use of the self-portrait throughout his career as a vehicle to question his persona, role and position in society was an expressive and liberating influence for him, and contributed to an understanding of self-portraiture as a fundamental means of self-scrutiny.

The invention of photography in the 1830s was partially responsible for a major re-evaluation of the role of the artist, and occurred when not only the artist's position within society, but also the function of the resultant product, was the subject of debate. The camera released the artist from many of the formal considerations of representation, and the degree of artistic freedom enjoyed by artists blossomed: consequently the range of subject matter considered appropriate for art and aesthetics expanded at an unprecedented rate.

Of course photography was only one contributory factor to this development; other artistic, political and scientific achievements occurred – the spirit of the rapidly changing times demanded more of its artists than mere representation or allegory could accommodate – the environment that engendered the modern movement had coalesced. Inevitably observational representation suffered a set back in the wake of modernism, the function of portraiture was fundamentally questioned; it would not therefore have been unreasonable to assume that self-portraiture would also be in jeopardy; however this was not the case.

The publication in 1885 of Freud's *Studies in Hysteria* established a blueprint for psychoanalysis, introduced the concept of the human subconscious and took merely 25 years to impose itself upon society; amongst the first to assimilate these studies were artists. As the events of the twentieth century unfolded, the artist's position as cultural catalyst became increasingly plural – altering from a primarily outward, reflective role to a stance which encompassed an increasingly introspective evaluation of the individual.

Thus at a critical juncture in art history, when the traditional function of the artist was being re-evaluated, and increasing emphasis placed upon the ego, the authority of artists became invested with almost shamanistic powers. Whether observed in Max Beckmann's scathing self-referential critiques of the 1930s, or Jackson Pollock's metaphoric and mythologised output of the 1950s, the concept of autobiographical work had gained a new and unfettered currency.

Couched within our invitation to participate in *The Self-Portrait: A Modern View* was a desire both to see how contemporary artists would approach self-portraiture in the light of such precedents and to gauge the degree of stylistic diversity that contemporary self-portraiture could now encompass. The resultant works are a fascinating assessment of the vitality of this particular oeuvre.

The list of artists invited was eclectic: for some self-portraiture was already a continual reference point, for others our invitation prompted their first self-portrait. We were concerned to include a number of artists whom one would not normally associate exclusively with representational work. The willingness of artists to accept such an invitation, and the diversity of the work produced, is a testament to their ability to use self-portraiture in a revelatory and autobiographical way. Whilst many of the works created are indeed representational self-

portraits, it is fascinating that many artists chose to continue extending the conceptual boundaries of self-portraiture and create self-portraits that are clearly part of their developing body of work.

This presents a challenging and absorbingly fresh interpretation that serves to inform us of the historical relevance of self-portraiture and highlights a current issue concerning many artists, that of viewing works produced as individual elements of a cumulative self-portrait which, inevitably, is not fully complete until the latter stages of the artist's career.

Whilst researching the project a number of points became evident: the paucity of previous documentation on self-portraiture; the scarcity of existing sculptural self-portraits, and also that relatively few women artists had left the legacy of a self-portrait. The latter observations are undoubtedly due to the historical systems of power and patronage within the art world which broadly mirror the structure of society. It is therefore gratifying that within this exhibition we have been able to include a substantial proportion of work from sculptors and from women artists. It is particularly pleasing that established artists accepted the invitation and challenge to create a self-portrait and be exhibited alongside a generation of younger artists, many of whom are currently establishing their reputations.

The recent exhibition *British Art in the Twentieth Century*, organised by the Royal Academy, undertook to assess the impact and strength of British art this century. The most obvious truism highlighted by the exhibition was that, unlike many of its European counterparts, British art is incapable of categorisation or identification by coherent stylistic groupings or schools. The artists whose reputations were enhanced by inclusion in the exhibition were those who had pursued their own idiosyncratic vision. Perhaps the only generically identifiable school of British art in this century is one of stylistic diversity and non-conformity.

The Self-Portrait: A Modern View does not attempt to categorise artists or place them within artificial groupings; rather, it is an opportunity, in the light of the return to figuration and the newly emergent

confidence being enjoyed by British art and artists, to evaluate the wealth of talent and stylistic diversity that currently exists.

One could hardly have imagined that Harry Holland's almost casual observation could have developed into such an absorbing and significant project. The artists' enthusiasm for the exhibition has been matched by interest from the public and media, resulting not only in the publication of this book but also in a major documentary television programme for Channel Four.

Inevitably such a large project as *The Self-Portrait: A Modern View* is the product of a number of fruitful collaborations. I would like to thank: Harry Holland for the idea in the first instance; Edward Lucie-Smith for the informed essay which constitutes the heart of this book, published to coincide with the exhibition; Mary Thomas for her steadfast and continuing support; Gordon Rookledge, Melissa Denny and Sarah Rookledge who have worked so conscientiously to realise the publication; Kate Darby, Assistant Director of Art, Bath International Festival and the staff of Artsite Gallery for their commitment to organizing the exhibition and subsequent extensive tour; Kenneth Price, HTV Producer and Director, who made the programme which documents the exhibition and Michael Kustow, Commissioning Editor for Arts, who commissioned the programme for Channel Four. Many of the artists included in *The Self-Portrait: A Modern View* are represented by private galleries whose assistance has been invaluable.

I am delighted that IBM United Kingdom Trust is so generously sponsoring the exhibition, its national tour and associated education programme. The value of this sponsorship is not solely financial, it is also testimony to IBM's continuing enlightened support for the contemporary visual arts.

Finally my thanks go unreservedly to the 61 artists for the creation of their self-portraits which are individually fascinating and collectively constitute an outstanding body of work. Without their commitment and enthusiasm neither the exhibition nor this book would have become a reality.

The Self-Portrait: a Modern View organised by
Artsite Gallery, Bath International Festival

Following its initial exhibition at Artsite,
1 Pierrepont Place, Bath
from September 19th–October 25th 1987,
the exhibition subsequently toured to

Durham Museum and Art Gallery

Ferens Art Gallery, Hull

Stoke on Trent City Museum and Art Gallery

Collins Gallery, Glasgow

Hatton Gallery, Newcastle

Glynn Vivian Art Gallery and Museum, Swansea

Graves Art Gallery, Sheffield

Fischer Fine Art, London

Mostyn Art Gallery, Llandudno

 The Self-Portrait: A Modern View, exhibition and national tour,
sponsored by IBM United Kingdom Trust

EDWARD LUCIE-SMITH

Ludwig Goldscheider, author of what is still the most comprehensive book on self-portraits, first published in Austria as long ago as 1936, claims in the very first sentence of his introduction that 'much has been said and written about the subject.' This was, and is, both true and untrue. It is true if one is prepared to search the enormous literature of art for scattered references, it is untrue if one looks for books devoted exclusively to the theme. Goldscheider has found few followers, and the only collection of illustrations that remotely rivals his own is Michelangelo Masciotta's *Autoritta da XIV° al XX° Secolo*, published in 1955. Masciotta reproduces 263 self-portraits to Goldscheider's 500, and neither of them devotes much space to twentieth century art. Both seem to have been more interested in collecting examples of self-portraiture than in speculating about their possible meanings.

In the brief introduction to his corpus of illustrations, Goldscheider points out that self-portraiture is very ancient. It can be traced back as far as Old Kingdom Egypt, which effectively makes it as old as portraiture itself. One of the examples which he cites forms part of a narrative relief found in an Old Kingdom tomb at Sakkara. But this portrait is not very strongly characterised — it is identifiable for what it is solely because the artist has taken the trouble to inscribe his own name above it.

The case is different with a remarkable Egyptian self-portrait of later date which came to light in 1963, when it appeared on the London art-market and was purchased by the Berlin Museums. It forms part of a quartzite stele which dates from the Amarna Period (*c.*1365 BC – *c.*1349/47 BC). At this time Egyptian art took a brief lurch towards extreme naturalism, under the influence of the religious doctrines professed by the 'heretic pharaoh'. Akhenaten.

On the stele the Pharaoh's 'Chief Sculptor' Bak and his wife, Taheri, appear full length, standing in a shallow niche, looking directly out at the spectator. The woman is a conventional Egyptian beauty, wearing a heavy wig and a tight-fitting dress that reaches to her ankles. Bak is quite different: squat, powerful with a large pot-belly, and brooding, somewhat negroid features. His physical presence is slightly grotesque, but also instantly memorable.

Egyptian portraiture, at least until the painted Fayum mummy portraits of Roman times, was always invariably of the rich and powerful — rulers, their families, the highest officials and senior members of the priesthood. Bak certainly occupied a

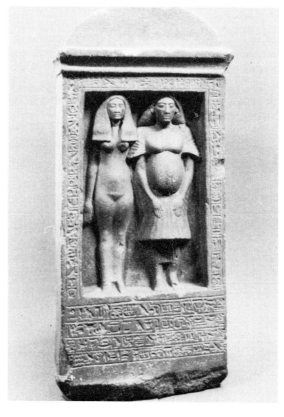

Stele of the sculptor Bak. Ancient Egypt, Amarna Period. Aegyptische Sammlungen, Berlin Museums

place in this hierarchy, as the description 'Chief Sculptor' shows, but just how exalted was it? One may suspect that the quality of the portrait far outstrips his rank. And this is one of its fascinations — it gives us an intimate glimpse of a different layer of society — workaday, ambitious for money and position, but also a bit pretentious in its social aspirations. For example, Bak's costume is a conspicuously elaborate example of court dress, and also conspicuously unbecoming. It is even more fascinating that the somewhat unfavourable verdict encapsulated in the sculpture was in fact delivered by the subject himself. But did he know what he was telling us? Bak's stele is a reminder that, while we know a number of self-portraits from the ancient world, we also know very little about the psychological motivations which inspired them.

What are we to make, for example, about one of the best-known Greek self-portraits? Plutarch tells us that the great Greek sculptor and architect Phidias, responsible for the sculptures of the Parthenon, placed a small portrait of himself on the shield of the cult statue of Athena, which stood in the temple's innermost shrine. A Roman copy of the shield survives in the British Museum. It is dec-

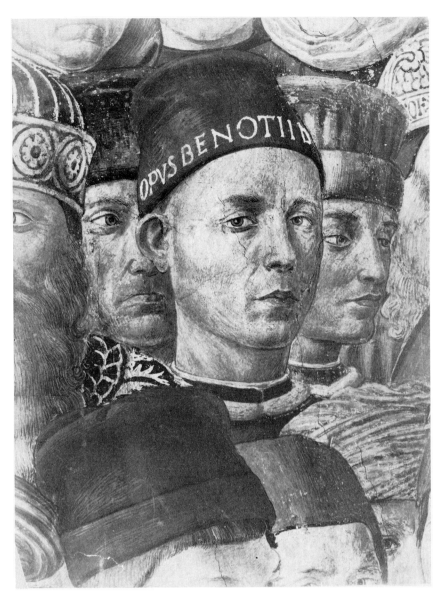

Benozzo Gozzoli, self-portrait from the *Procession of the Three Kings*, 1459. Palazzo Medici-Riccardi, Florence

individuality. In addition, some Renaissance art-theorists represented the self-portrait as being the origin of art itself. The architect Leon Battista Alberti (1404–72) declared that 'Narcissus, who saw his reflection in the water, and trembled at the beauty of his own face, was the real inventor of painting.'

Among the best-known of these 'signature' portraits are the two heads of Lorenzo Ghiberti which form part of the frame decoration of his bronze doors for the Florence Baptistry; the curiously baleful self-portrait of Benozzo Gozzoli which appears in his fresco *The Procession of the Three Kings* (1449) in the Palazzo Medici-Riccardi; and Masaccio's supposed self-portrait in *The Tribute Money (c.*1425/8) in The Brancacci Chapel of S. Maria del Carmine.

In fact, the Masaccio self-portrait offers a warning. We can be sure of the identity of Gozzoli's self-portrait because the artist has put his name on the hat, though slightly mysterious is the mood of dis-satisfaction that the face conveys. The identity of the figure which is supposed to represent Masaccio is a good deal less certain – it rests only on the authority of Giorgio Vasari, whose *Lives of the Artists* was not published until 1550, more than a century after Masaccio's death.

Similar identifications have been made in works by fifteenth century Netherlandish artists: Jan van Eyck, in a detail from the Ghent Altarpiece; Roger van der Weyden, as St Luke, in *St Luke Painting the Virgin* (Boston); Dirk Bouts as the watchful servant at the extreme right of his *Last Supper* in Louvain Cathedral. These 'self-portraits' have met with very varying degrees of acceptance and are in fact con-sistently less well-established than corresponding Italian examples from the same period.

Despite this, the independent self-portrait, created purely for its own sake, seems to have begun in northern Europe rather than in Italy. An extremely early – perhaps indeed the earliest-surviving example is Jean Fouquet's likeness of himself which dates from around 1470. But this miniature in enamel was not originally as indepen-dent as it now seems. It is almost certain that it orig-inally decorated the frame of a larger work, the Melun Diptych.

The first artist to make self-portraiture a major part of his activity was Albrecht Dürer (1471–1528). Dürer's self-portraits cover a wide range of different moods, and, one may conjecture, an equally wide range of different purposes. The series begins when the artist was still an adolescent, with the silverpoint drawing of 1484. Then comes the handsome youth of 1493 in the Louvre (Dürer advertising himself as a potential husband), and the equally handsome young man in the Prado (Dürer celebrating his own worldly success). In each of these the artist is at some pains to stress his own fashionability and, still more so, an air of breeding. In them the artist is regarded not as being merely a superior kind of artisan, as had been the case in the recent past, but as an important individual. These pointedly elegant

orated in relief, with a battle between Greeks and Amazons, and, sure enough, one of the Greek war-riors is noticeably less idealised when compared to the rest. He has a bald forehead and a bulging brow. Phidias is said to have died in prison, and one account lays the blame on this very self-portrait – the sculptor was accused of impiety for having placed his own image in the temple's holy of holies. The story suggests that two powerful impulses col-lided: the feeling that Athena's image should be seen solely as a manifestation of the divine, no matter who had been responsible for creating it; and the human desire to claim credit for a work universally acknow-ledged to be marvellous.

The use of the self-portrait as a kind of signature reappears in the Middle Ages. The architects of the great cathedrals occasionally used their own like-nesses as an inconspicuous part of the sculptured decoration – there are well-known examples in the cathedrals at Santiago di Compostella and in Prague. The self-portrait employed in this way found addi-tional favour during the Renaissance. This is not sur-prising, since one of the main characteristics of the Renaissance, compared to the period that had pre-ceded it, was a much increased emphasis on human

portraits reflect the fact that Dürer felt keenly any slight on his social position. In 1506, writing home from Venice to his friend Willibald Pirckheimer, he said bitterly: 'Here I am a gentleman, while at home I am a parasite.'

Before this date, however, his self-portraits had begun to change. In Munich there is a painting, dated either 1500 or 1506, in which the artist shows himself in a quite different guise to those he had assumed previously. Now he takes a pose derived from the traditional image of Christ as the Saviour of the World, and wears an elaborate braided coiffure. The painting, which has disconcerted Dürer's modern admirers, is meant to tell the spectator two things: first, that the artist has gifts which separate him decisively from the rest of mankind; and secondly that his creative power is an aspect of divine creativity – it derives from and is actually a part of the power of God Himself. The message is repeated and reinforced, though in a far more pessimistic tone, in a late drawing of 1522 in which Dürer has used himself as the model for *Christ as the Man of Sorrows* (Kunsthalle, Bremen).

But Dürer's use of religious imagery was an anxious, rather than a confident one. As he grew older, he became increasingly preoccupied with the doctrines of the great Protestant reformer Martin Luther. What we glimpse in the late self-portraits is a belief central to Protestantism – that man is responsible for his own fate, and must be prepared to face his Maker without human mediators, and certainly independent of religious hierarchies. Something of this feeling has clung to the self-portrait ever since, no matter what the religious persuasions of the artist.

In the sixteenth century self-portraits were produced in increasing numbers, both in the North and in Italy. They reflect equally the rising social status of the artist, and a sharpened interest in the special nature of the creative personality. Titian's self-portrait of *c*.1560 in Berlin incorporates both themes in a single formidable image – this is the man who at that time consorted daily with the most powerful individual in Europe, the Emperor Charles V. According to one anecdote, the Emperor once stooped to pick up the painter's brush for him, when it had fallen to the floor, a mark of the respect in which he was held.

Certain works have an amusing flavour of their own, inspired by the Mannerist liking for virtuosity and for complicated visual conceits. In about 1523, the young Parmigianino (1503–40) painted his own likeness as seen in a convex mirror, faithfully copying the distortions this produced. The painting served as an effective advertisement for his skills, at a time when he was not as yet established. He took it with him to Rome, then still (before the Sack of 1527) a fount of patronage, and it provided him with a rapid introduction to the art-loving Pope Clement VII.

Michelangelo, one of the most complex of all the artistic personalities of the sixteenth century, is

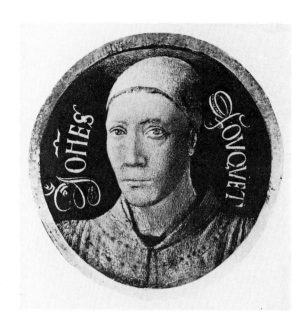

Jean Fouquet, *Self-Portrait*, c.1470. Louvre, Paris

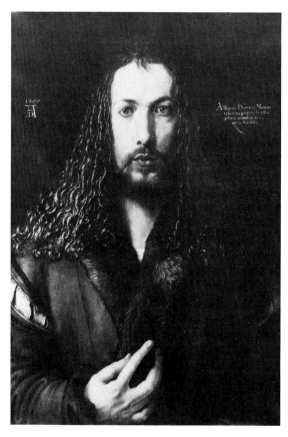

Albrecht Dürer, *Self-Portrait as Saviour of the World*, dated 1500 or 1506. Alte Pinakothek, Munich

credited with two self-portraits, neither of them in the least conventional. Both tell us something about Michelangelo's relationship with his religious faith – he was as much a child of the Counter-Reformation as Dürer was a child of the Reformation itself. The first portrait appears as part of the *Last Judgement* in the Sistine Chapel. One of the most prominent of the attendant saints is the apostle St Bartholomew, and the artist's disorted likeness appears on the flayed skin which the figure dangles from one massive hand. The choice of this grotesque image has been attributed to a strange mixture of self-abasement and self-assertion. But it also has a specific religious meaning. St Bartholomew, martyred by being flayed alive, is traditionally associated with

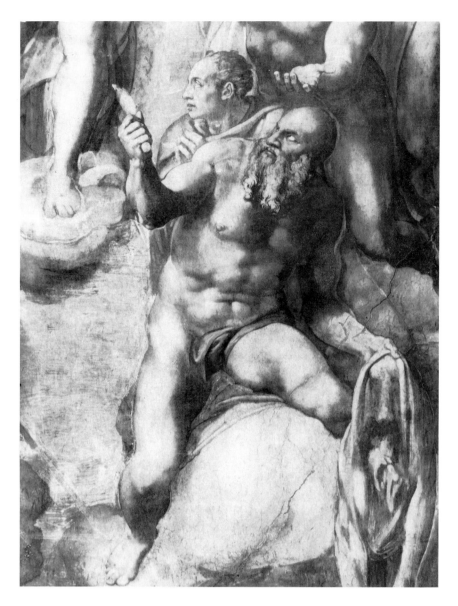

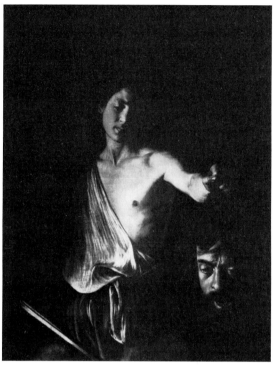

a phrase from the Apostles' Creed 'Credo in Spiritum Sanctum'. Michelangelo seems to be asserting that his inspiration comes directly from the Holy Spirit.

The second self-portrait appears as the head of Nicodemus in the unfinished *Pietà* which Michelangelo intended for his own tomb. The Pharisee Nicodemus is associated with the idea of salvation through faith – in the Gospels Christ says to him: 'In truth, in very truth I tell you, unless a man has been born over again he cannot see the kingdom of God.' (John, 3.1). In his book on Michelangelo Howard Hibbard interprets the portrait as 'a personal *concetto* – the likeness of Michelangelo, burying Christ in the likeness of Nicodemus/Joseph, stands over the grave of Michelangelo, who hopes to be saved through faith.'

The turning point between Mannerism and the Baroque style which succeeded it is marked by the emergence of Michelangelo's namesake, Michelangelo Merisi da Caravaggio (1573–1610). Like his great predecessor, Caravaggio had a taste for self-portraits which took unexpected and startling forms. Quite a number of his paintings, especially the early ones, have been described as self-representations – the label has even been pinned on

the grimacing head of *Medusa* in the Uffizi, supposedly painted when the artist was still a beardless adolescent. The two most widely accepted self-portraits are a background figure in the *Martyrdom of St Matthew* in S. Luigi dei Francesci in Rome – a late example of the self-portrait-as-signature – and the severed head of Goliath in the Galleria Borghese *David and Goliath*. This image, too, carries a theological message; a highly pessimistic one. St Augustine gives the intended meaning: 'As David overcame Goliath, this is Christ who kills the devil.' Caravaggio seems to be presenting himself as a man who is almost certainly damned. For twentieth century spectators, the picture carries another meaning as well. Freudians interpret images of decapitation – and they occur frequently in Caravaggio's art – as being related to fears of impotence or castration, and thus linked to homosexuality. There is contemporary evidence that Caravaggio was homosexual, or, at least, bisexual, and one mid-seventeenth century writer goes so far as to hint that the David in the picture is also a portrait, of the artist's catamite.

The most intense self-study known to art is the long series of self-portraits by Rembrandt (1606–69).

It stretches from his first period of professional activity in Leiden right through to the end of his life. The external events of that life are well documented. Rembrandt moved from Leiden to Amsterdam circa 1631/2 and scored an immediate success there. In 1634 he married a girl of good family, Saskia van Uylenburch, and started to live in considerable style. His wife died in 1642, and from the same period dates a gradual decline in his popularity, as his work grew more original and difficult, though he never lost his attraction for young artists and continued to have numerous pupils. Soon after his wife's death Rembrandt took a mistress, the nurse of his young son Titus, but within a few years she was supplanted by another girl of humble origin, the sergeant's daughter Hendrickje Stoffels. This in turn led to a bitter case for breach of promise when the first incumbent tried to force the artist to marry her. Rembrandt had to provide the plaintiff with an annuity, but Hendrickje was left in possession. She continued to live with Rembrandt for the rest of her life, but the couple never married, perhaps because of the terms of Saskia's will. Rembrandt's financial affairs, already entangled because of his extravagance as a collector, received a fatal blow from the economic depression triggered off by the first Anglo-Dutch War, and in 1656 he went bankrupt. His property was dispersed at a series of auctions, and he was forced to move to a smaller and less central house. Hendrickje and his son Titus formed a company to look after his interests, and henceforth he was technically their employee. But neither outlived the artist – Hendrickje died in 1663 and Titus in 1668, a year before his father.

These facts provide a framework for the interpretation of the self-portraits, but the drama the pictures themselves present is an interior one. They speak of human growth and evolution, no doubt influenced by external events but with a dynamic independent of them. The self-portraits change in character and purpose as Rembrandt's artistic development progresse. When he was still young and not yet established, he was himself the most readily available model. His very first self-portraits, such as the one in Kassel, date from *c.*1629. There is something tentative about them, not in technique, but in their approach to the subject. In the Kassel portrait, the whole of the upper half of the face is in deep shadow, which seems to symbolise shyness. A little later, there is an uneasy boldness; the portraits are now studies in expression; the young Rembrandt grimaces at himself in the mirror. When he moves to Amsterdam, this uneasiness vanishes; the now successful painter gazes out at us smugly, wearing rich clothes and a fashionable moustache as the emblems of his success. Soon, however, he grew bored with a straightforward presentation, he began to wear costumes which become more and more outré. But this phase passed too, the fine self-portrait in the National Gallery, London, signed and dated 1640, showing the painter swathed in a rich cloak, resting his elbow on a parapet, pays dignified

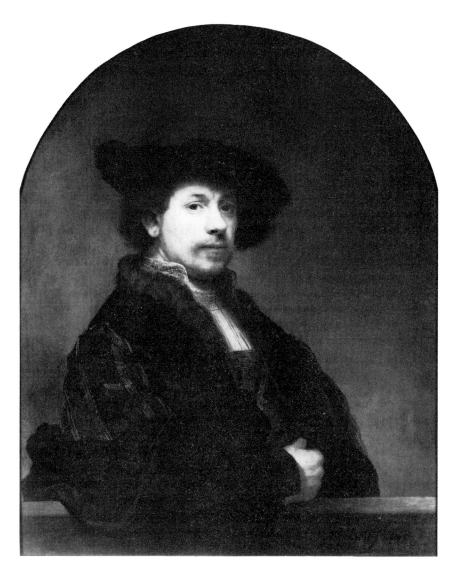

homage to Titian. The composition echoes an early Titian portrait in the same collection.

During the next decade, the self-portraits become less frequent, then, just as the artist's financial troubles begin to close in upon him, he returned to the theme with renewed vigour. The painting dated 1652 in Vienna is the boldest statement he had yet attempted – Titianesque in a different sense. The handling is broader, and Rembrandt gazes straight out at the spectator, as if daring him to comment on what he sees. There are other differences as well; the fine clothes have been discarded, the gaze is melancholic as well as challenging, the features have begun to coarsen. Self-portraiture was to be one of the main themes of Rembrandt's art during his final two decades, and the way in which the paintings are conceived becomes increasingly unconventional. The costume is now slovenly, the features 'ugly and plebian' (in the phrase used by the contemporary Italian writer Baldinucci, when discussing Rembrandt's appearance), yet the sense of direct communication with the spectator is increasingly strong. Very late in the series comes an astonishing painting of about 1668 in the Wallraf-Richartz Museum, Cologne. In it, Rembrandt shows himself laughing, though the face, now, is a sagging ruin. In his recent book on Rembrandt Christopher White

Rembrandt, *Self-Portrait*, dated 1640. National Gallery, London

Rembrandt, *Self-Portrait Laughing*, c.1668. Wallraf-Richartz Museum, Cologne

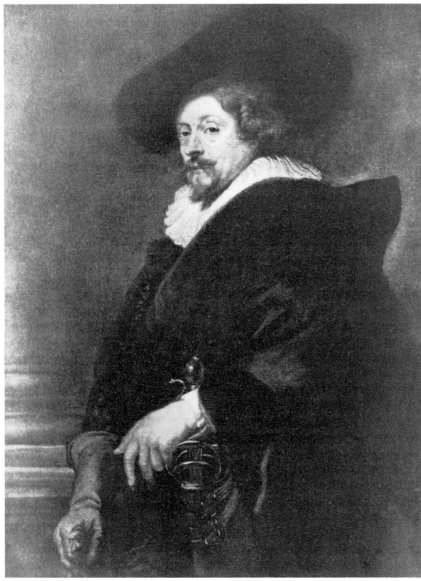

Rubens, *Self-Portrait*, c.1636. Kunsthistorisches Museum, Vienna

suggests that the artist has here shown himself as the Ancient Greek painter Zeuxis. In the early seventeenth century the Dutch art-theorist Carel Van Mander gave a vivid description of Zeuxis's death: 'he departed this life laughing immoderately, choking while painting a funny wrinkled old woman in the flesh.'

Why was the self-portrait so important to Rembrandt? It is worth remembering that his work, even more than Dürer's, comes from a specifically Protestant tradition, and is subsumed by the same doctrine of personal responsibility. In addition, the Protestantism of the society in which he worked, coupled with his own loss of popularity, meant that Rembrandt's opportunities for making major public statements on serious themes were somewhat restricted, certainly compared to those available to his prolific contemporary, Peter Paul Rubens (1577–1640). As a Catholic artist, working for a Catholic clientele, though not exclusively, Rubens was asked to provide numerous altarpieces and other sacred pictures. His patrons included the Catholic rulers of Europe, anxious to commission paintings which would glorify their temporal power, and unoffended by the pagan themes which middle-class Dutch Protestant clients regarded as too sensual. Though Rembrandt painted episodes from the Old and New Testaments, just as Rubens did (though Rembrandt put special emphasis on Old Testament stories and on the Passion), these paintings are seldom on a monumental scale, and public commissions, even for secular pictures, were few indeed. The last of these, *The Conspiracy of Julius Civilis*, which Rembrandt painted in 1661–2 for the Town Hall in Amsterdam, was not a success; it was removed after only a year, and replaced by a work done by an inferior artist. In the circumstances it is not surprising that self-portraits became an outlet for feelings and ideas concerning the nature of human existence which found no satisfactory channel elsewhere.

Though self-portraits are not absent from Rubens's oeuvre there are fewer than in Rembrandt's, and they are more closely related to external circumstances. The double portrait with Isabella Brandt, of 1609–10, is a celebration of the artist's first marriage; the self-portrait of c.1625 now at Windsor was requested by the artist's patron Charles I who 'entreated me so urgently for a portrait of myself that I could not refuse.' From a psychological point of view the most revealing self-portrait painted by Rubens is the painting of c.1636 now in Vienna. In this the artist presents himself as an aristocrat, with his sword of knighthood (presented to him by Charles I) and one glove negligently dangling. But the expression is far from being smug – instead it is reserved, and a little weary. He offers much less of himself to the spectator than Rembrandt does.

In the seventeenth century there was both a passionate interest in the roots of human personality and a more specific fascination with the nature of artistic creativity. As a result almost every successful

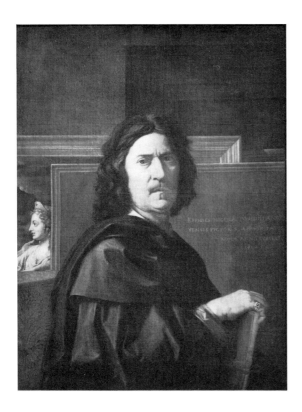

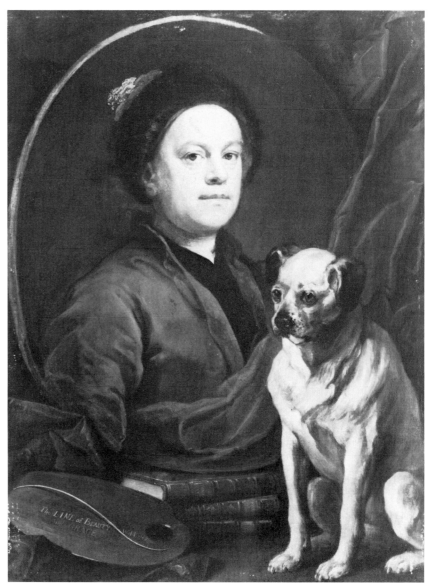

artist attempted the self-portrait, even if portrait-painting was not his usual occupation. Hals and Van Dyck painted striking self-portraits, as one might expect, but they are closely rivalled by those of the sculptor Gianlorenzo Bernini, by the devotional painter Carlo Dolci, and by the great classicist Nicolas Poussin. Van Dyck's self-portraits are quite numerous, and cover the whole of his career; the earliest seems to have been done when he was only sixteen. The most striking was painted in England, c.1633, when Van Dyck was court-painter to the art-loving Charles I. In it he displays the gold chain given to him by the king, and points to a gigantic sunflower, the emblem of royal favour. More reserved, yet more profound, is the self-portrait by Nicolas Poussin (1594–1665) in the Louvre. Poussin, living in Rome and unable to find a professional portrait-painter who satisfied his exacting standards, painted it for his friend and patron Chantelou, back home in France. It is supremely detached and objective; Poussin's temperament and preferences show themselves in unexpected ways – for example, in the method of organising the background. The figure is posed against rows of overlapping canvases, stacked against the wall; and the rhythm of these creates a subtle sense of underlying order.

Diego Velasquez's (1599–1660) *Las Meñinas* (The Maids of Honour) is, in one sense, the ultimate elaboration of an already very well-established type of self-portrait, in which the artist shows himself at work in his studio. This genre has a long history, derived from late medieval representations of St Luke painting the Virgin. In these, as has already been said, it became customary for the artist to use his own likeness. But *Las Meñinas* is unique in that, as the title suggests, the artist is here not the main, certainly not the only, subject of his vast canvas.

The picture shows Velasquez at work on a painting with, in the foreground, the Infanta Margarita and her attendants. His activity has apparently just been interrupted by the arrival of Margarita's parents, Philip IV of Spain and his Queen. For a moment time is suspended, there is a meditative pause, and this – the hiatus between thinking of what is to be created, and actually creating it – is the real subject. Velasquez is thus only one of the actors, though an important one, in an allegorical tableau which has nevertheless been disguised as an episode from life. This is less a portrait of the artist than of art itself.

Taken as a group, the self-portraits of the seventeenth century are perhaps the most brilliant and the most profound ever to have been painted. From about 1680 onwards, there is a perceptible drop in emotional temperature. Artists continue to paint their own likenesses, but now it has become a routine task – the successful artist is expected to commemorate his own appearance, as part of his claim to be a member of the professional class, rather than a simple artisan. All too often, elaborate wigs and fine clothes become more important than the expression of character or feeling. There are, of course, exceptions to this rule. Some of the most

Above left:
Nicholas Poussin, *Self-Portrait*, dated 1649. Louvre, Paris

Above right:
William Hogarth, *Self-Portrait with his Pug*, 1745. Tate Gallery, London

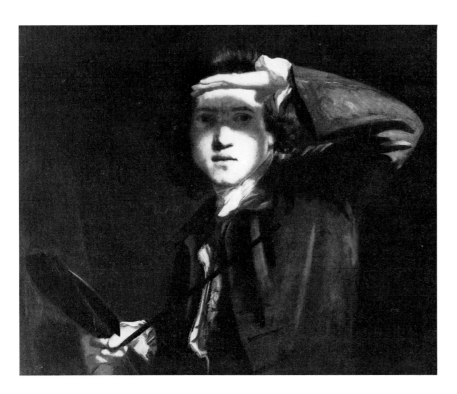

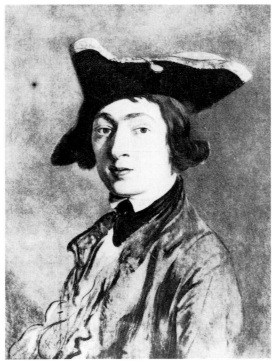

Joshua Reynolds, *Self-Portrait*, 1753–4. National Portrait Gallery, London

Thomas Gainsborough, *Self-Portrait*, 1754. Marquis of Cholmondeley, Houghton

striking occur in France, where the development of the literary salon and its attendant cult of conversation bred a keen eye for human quirks, and an equally sharp one for pretension. Few portraits of any age are more direct than those by the pastelist Maurice Quentin de La Tour (1704–88), and of all his works the likenesses of himself, finished and unfinished, are perhaps the most striking. They convey a complex personality: sardonic, sceptical and civilized.

Compared with these, English self-portraits of the same epoch are clearly less sophisticated. Yet, and not just for reasons of cultural chauvinism, I feel that they are collectively the most successful of their time. Some of the best English self-portraits of the eighteenth century lay great and conscious stress on the quality of 'Englishness'. This is certainly the case with Hogarth, gazing rather stolidly out at us from the shelter of an oval canvas propped on the works of Shakespeare, and where a continental master might have made some suitable allusion, or allegorical reference to the artist's reputation, there is just a palette and the mundane likeness of Hogarth's dog, Trump. Gainsborough's early self-portrait, wearing a tricorne hat, is less trenchant, but it has an air of candour and relaxation which is in tune with the English society of the time. Joshua Reynolds, even in youthful self-portraits, struggles hard for something more impressive; in later ones he adapts what he had learned from Rembrandt to English taste, but still preserves a surprising, and endearing, air of vulnerability.

At the end of the eighteenth century. France produced two artists whose self-portraits were significant for the future, though their gifts were not on the same level. The lesser of the two was Elizabeth Louise Vigée Le Brun (1755–1842), who before the Revolution was Marie-Antoinette's favourite portraitist, and who, going into exile, became a hugely successful itinerant painter who portrayed both the local nobility and the scattered survivors of the Ancien Régime in Italy, Austria and Russia. She was able to return to France after her name was struck from the lists of emigrés as the result of a petition signed by no fewer than 255 artists, writers and scientists, but continued her travels even when she was again free to reside in France, visiting London after the signing of the Peace of Amiens in 1803 and achieving a considerable success there.

Vigée Le Brun was not the first successful female painter but she did have a unique quality – the power to create an alternative world, where feminine sensibility could reign untrammelled. This was the secret of her success with female sitters, who formed the greater part of her clientèle. She exercised a tremendous influence over women's fashions; the catalogue of the retrospective exhibition of her work, held at the Kimbell Art Museum, Fort Worth, in 1982, asserts that 'perhaps more than any single individual in the last quarter of the eighteenth century, Vigée Le Brun influenced the development of women's costume.' In her *Souvenirs*, published in old age, the artist describes the style she set: 'I wore only white gowns of muslin or lawn . . . My hair cost me nothing. I styled it myself.' But things went further than this; she pioneered a new attitude to the world, a reaction against over-sophistication. The change extended to facial expression as well as to details of dress. 'In much of her portraiture,' remarks the Fort Worth catalogue, 'the smile works as a kind of *leitmotiv* denoting genteel sensibility.' Vigée Le Brun's self-portraits, especially those painted early in her career, before the Revolution, served primarily as advertisements for her skill. But they also did more than this, they offered prospective sitters a role-

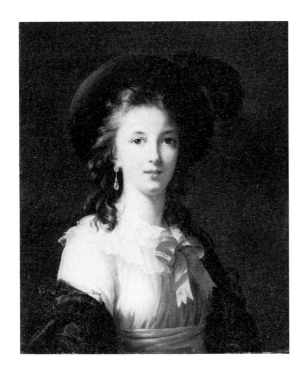

Elizabeth-Louise Vigée-Lebrun, *Self-Portrait*, c.1782. Kimbell Art Museum, Fort Worth, Texas

model to which they were already eager to conform.

The case is different with a famous self-portrait painted by Jacques-Louis David (1748–1825), Vigée Le Brun's contemporary, but very much on the opposite side of the fence politically. David was the most powerful and original artist of his day, and the one who became most deeply committed to the Revolution. In 1792 he was elected as a deputy to the National Convention, where he sat with the Jacobins, the most radical faction. In January 1793 he voted for the death of Louis XVI. It was the turn of Danton in the January following, and David attended his execution and abused him without pity. When Robespierre and his fellow Jacobins fell in July 1794 David, who had been so close to them, was inevitably involved in their overthrow and was lucky to escape with his life. Though he was not executed, he was for a while imprisoned. During this period of disgrace he painted the picture which now hangs in the Louvre. It would be hard to better the description which Anita Brookner gives in her book on the artist:

> Painted as a direct utterance, on to a freshly primed canvas, the portrait seems to be of a young man to whom a great wrong has been done. But he is not young: he is forty-six years old, and although his hair is brown, the stubble around the coral mouth is greyish. The expression on the face is one of baffled honesty; the hands, grasping the palette, are tense with the desire to explain, something that David had proved himself totally unable to do. It is all there: the anxiety, the grievance, the innocence, the isolation, and the bewilderment that remains after short-lived exaltation.

David's portrait is not a meditation on self, in the sense that this term can be applied to the late self-portraits of Rembrandt. It is, and in this it does resemble the much more superficial self-portraits of Vigée Le Brun, a projection of self, and in this case of the specific situation in which the artist found himself. The same is true, in a much more self-conscious way, of the even more celebrated *Self-Portrait with Dr Arrieta*, painted by Francisco Goya (1746–1828) in 1820.

David and Goya are often regarded as antitheses – one the representative of Neo-classicism, the supporter of system and order in the visual arts; the other a painter who passed from the frivolity of the Rococo to the *terribilitá* of Romanticism, flouting as he did so all the rules which David and his supporters tried to lay down. But both men lived through the same tremendous epoch, that of the Revolution and the Napoleonic Wars which followed, and inevitably both were influenced by it. Goya's *Self Portrait with Dr Arrieta* commemorates a turning point in the artist's life; recovery from an apparently mortal illness. Furthermore, the image is not straightforward – the sick man seems disposed to struggle against his saviour; in the background are mysterious, sinister figures which recall the demonic presences in Goya's 'Black Paintings', which date from the same epoch. The psychic turbulence which is still half-repressed in David's self-portrait is here completely overt, to a degree previously unknown in art. Yet at the same time this is a painting with strongly traditional elements, at least in Spanish terms – it is like an old-fashioned votive image, to be hung in a church.

Goya's career terminated just before the invention of photography. All the artists I shall discuss from this point onwards belong to the post-photographic era. While the camera affected every aspect of painting, it had an especially strong impact on portraiture. Having one's portrait made ceased to be the privilege of the few; and the photographic image immediately set a new standard of verisimilitude and likeness to the subject. At first it seemed as if the painted portrait must succumb, that this mechanised and scientific competitor was bound to make its rival obsolete. This did not happen for a variety of reasons: photographs remained small in scale, the images were for a long time monochrome, and painting retained its prestige as a sumptuous luxury object. There was also another reason – people discovered that the camera, with its power to halt for a second the passage of time, tended to produce a superficial and momentary likeness. It was the painter who retained the power to capture the complexity of human personality. Gifted portraitists more and more tended to concentrate on the things the camera could not convey, and this was perhaps especially true when artists attempted to make their own likenesses, and had no patron to please except themselves. The camera gave self-portraiture a decisive impulse towards subjectivity. Yet there is a paradox. Before this artists only knew their own features from what they could see in a mirror; that is to say a reversed image. Now they were able to see how they appeared to others.

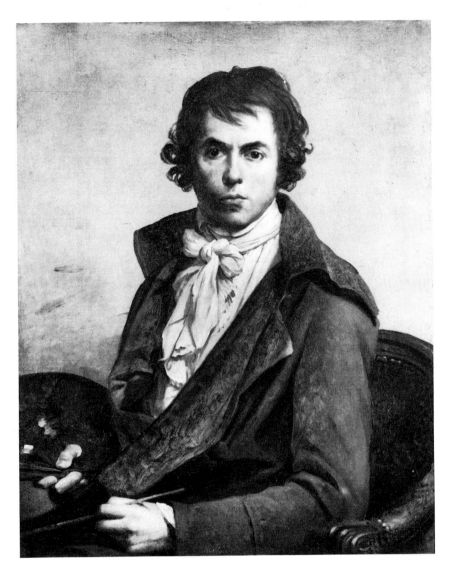

Jacques-Louis David, *Self-Portrait in Prison*, 1794. Louvre, Paris

Gustave Courbet, *Bonjour, M. Courbet*, 1854 Musée d'Orsay, Paris

A new spirit appears very clearly in the work of Gustave Courbet (1819–77), the most prolific self-portraitist of the mid-nineteenth century. Courbet is usually presented as the leader of the Realist movement which succeeded Romanticism in France. Because of his political actions (his involvement in the Commune), as well as his known political views, he has chiefly attracted the attention of Marxist critics in recent years. But he does not fit the Marxist

framework comfortably. Even if one stays away from his figure-paintings, or perhaps one should say *particularly* if one stays away from his figure-paintings, his work has a strongly fantastic element. Many of his landscapes feature huge rocks and cliffs in which grotesque faces are concealed; they form a bridge between the world of Hieronymus Bosch and that of Salvador Dali.

One cannot be certain whether these landscape fantasies are the product of conscious manipulation, but the self-portraits certainly present Courbet's view of himself. They are notable for self-dramatisation, and each tends to show the painter assuming a particular role – Courbet displays himself as an itinerant Bohemian (*Self-Portrait with Black Dog*, 1842), as a victim (*The Wounded Man*, 1844–5), as a handsome wooer (*Lovers in the Country*, 1844), as a histrionic madman about to cast himself from a rock (*The Desperate One*, 1844), as a solitary (*Seaside at Palavas*, 1854), and as a wronged and noble prisoner (*Courbet in Sainte-Pélagie*, 1871–2). The two most complex of his self-portrayals are amongst his best-known works; *Bonjour, M. Courbet* (1854) and *The Studio* (1854–5). Both are statements about the role and importance of the artist. *Bonjour, M. Courbet* depicts Courbet's arrival at Montpellier as the guest of his patron Alfred Bruyas. The artist depicts himself as a free spirit, who is rightly greeted with deference by those who have come to meet him. The spirit of the work was well caught by a not altogether friendly critic, Edmond About, when the painting was shown in the Paris Exposition Universelle of 1855:

> M. Courbet has done full justice to the perfections of his own person: even his shadow is slim and vigorous, with well-turned calves such as you seldom see in the land of the shades. M. Bruyas is less flatteringly treated – he is a bourgeois. The poor man-servant is humble and self-effacing, as if he were serving Mass. Neither master nor man casts a shadow on the ground; M. Courbet alone has power to obstruct the sun's rays.

Courbet's subtitle for his huge masterpiece *The Studio* was *A Real Allegory Summing Up Seven Years of My Life as an Artist*. In it he has, to quote Robert Rosenblum's description, 'taken over the largest pictorial arena imaginable in order to offer, among other things, a new model of an artistic and social universe of which he is the center and sole creator.' The seven years to which Courbet referred had begun with the revolution of 1848, and he was making the claim that both public and private life could now find their best resolution in the artist's mind, which had become a stage on which all destinies could be acted out. The separate details to be found in the painting, all realistic enough in themselves, serve an abstract and symbolic purpose.

The Impressionists are often presented by art-historians as the direct heirs of the realist Movement led by Courbet. But this is too simplistic. Courbet's realism was largely a matter of negatives: he aimed

to avoid the self-censorship and self-serving idealisation which marked the work of his academic rivals. The Impressionists were far more radical than this. They wanted to see the world 'innocently', without preconceptions. For one group of Impressionist painters – Monet, Sisley and Pissarro – the actual mechanism of sight was more important than the thing seen. The importance of subject-matter in their pictures as therefore sharply diminished. None of these painters was of much interest or importance as a portraitist, and Sisley never painted portraits at all.

The case is different with Manet, Degas and Renoir, all important figure-painters, as opposed to landscapists who produced a number of portraits. Manet was a much better portraitist than self-portraitist. His likeness of his friend Georges Clemenceau, for example, is a brilliant character study, but when painting himself, he was inhibited. Manet's character, as Degas shrewdly noted, was full of contradictions – the latter once said to the Irish writer, George Moore: 'Manet is in despair because he cannot paint atrocious pictures like Durand and be fêted and decorated; he is an artist not by inclination but by force. He is like a galley-slave chained to the oar.' Moore himself added the observation; 'He was a rich man, an aristocrat in his dress and his manner; but to be an aristocrat in art, you must keep away from good society.' These contradictions appear more forcibly in the aloof and formidable likeness produced by Fantin-Latour than they do in any of Manet's few likenesses of himself.

Degas (1834–1917) came from the same high social level, and he, too, was inhibited about producing his own likeness – or about allowing it to be made by other people. His self-portraits belong to his youth; the best-known is the painting in the Louvre which dates from 1855. They show him as being very much the disciple of Ingres. For Degas these portraits were part of his apprenticeship. As soon as he achieved artistic independence he stopped painting them. As he grew older his misogyny and his sense of privacy grew more and more pronounced. Near the turn of the century, the society painter Jacques-Emile Blanche asked Degas if he might do his portrait, Degas agreed reluctantly, but only on condition that the picture remain unseen by the public. He never forgave Blanche for allowing an English magazine to publish it.

Surprisingly, the most moving and intimate self-portraits painted by a member of the impressionist group were the work of Auguste Renoir (1841–1919). This does not apply to one of the best-known, the likeness which appears in *Le Cabaret de la Mère Anthony*, painted in 1866, and now in the National Museum in Stockholm, though the artist himself retained a special fondness for this souvenir of his youth – he called it 'one of the pictures I most like to remember.' Nevertheless, the portrait itself is rather lacking in depth. Renoir's best likenesses of himself were painted in moments of sadness or misfortune. Two were painted shortly after the illness and death of a favourite model (and probable mis-

tress) Marguerite (Margot) Legrand, in 1897. The more finished of the two was given to one of the physicians who had looked after her (now in the Sterling and Francine Clark Art Institute, Williamstown, Mass.). It shows a tragic personality very much at variance with Renoir's legend. There is also an impressive group of self-portraits painted in old age, when Renoir was crippled with rheumatism and suffered agonies in order to paint. His ward Julie Manet, daughter of his old friend Berthe Morisot, left some notes in her diary about a portrait painted in 1899 (this, too, is in the Sterling and Francine Clark Art Institute): 'It is so painful to see him in the morning not having the strength to turn a door knob. He is finishing a self-portrait that is very nice, at first he had made himself a little stern and too wrinkled; we absolutely insisted that he remove a few wrinkles and now it's more like him, "it seems to me that those calf's eyes are enough," he says.'

By the time the picture was painted, the heyday of Impressionism was already over. The pendulum had swung to a very different kind of art. If self-portraiture played only a marginal role in the history of Impressionism, the case is different with Post-Impressionism, the movement that succeeded it.

Do we in fact have the right to describe Post-Impressionism as being an art movement at all, at

Auguste Renoir, *Self-Portrait*, 1897. Sterling and Francine Clark Art Institute, Williamstown, Mass.

Vincent Van Gogh, *Self-Portrait*, May 1890. Louvre, Paris

For Cézanne, his own appearance was simply a visual fact on a par with the other visual facts he tried to translate into paint – the Mont Sainte-Victoire and its surrounding landscape, or a still-life of fruit on a table.

The attitudes of the two other major Post-Impressionists were very different from Cézanne's. Paul Gauguin (1848–1903) was turned into a hero by the literary symbolists without being a fully paid-up member of their movement. His progress towards a fully developed personal style was as unorthodox as his background. His mother was a Peruvian Creole, and part of his childhood was spent in Lima. Later he joined the merchant marine, then became a successful stockbroker who painted in his spare time. Though he exhibited in the Impressionist exhibitions of 1880, 1881 and 1882, he created little impact and did not decide to become a full-time artist till 1883. The financial effects were catastrophic and the rest of his life was a constant struggle to survive. On the other hand, he was a natural leader, and became the chief figure in the Pont-Aven group in Britanny, which included many of the younger artists who were beginning to revolt against Impressionism. But even this was not enough to satisfy his restless ambition. Just as his work began to attract attention among the Parisian Symbolists, he left for the South Seas, where, with brief returns to Europe, he spent the remainder of his life. The canvases he painted in Tahiti and the Marquesas created for him the enormous personal myth which he had always coveted.

As one might expect, Gauguin's portraits are always highly self-conscious. He was aware of a parallel between his own nature and that of Courbet. He alludes specifically to the older artist in a painting entitled *Bonjour, M. Gauguin*, painted in 1880–1, which is one of his best early works. But he also shows a sardonic spirit of self-mockery which is foreign to Courbet's naively bombastic temperament. One of Gauguin's best-known self-images, painted in 1889 (National Gallery of Art, Washington), depicts him with a halo hovering over his head and a serpent emerging like a cigarette from between his fingers. Behind his head, which itself seems to float, unattached to any body, sways a twig with three ripe apples. The artist is thus teasingly represented as possessing supernatural powers, both for good and for evil. The conception is curiously reminiscent of Gauguin's English contemporary, Aubrey Beardsley, who also enjoyed flirting with diabolism.

The romantic and tragic life lived by Gauguin has helped to create our current popular image of the artist, as being, among other things, someone who is hopelessly at odds with modern technological society. This image, however, owes even more to Gauguin's sometime associate Vincent Van Gogh (1853–90). Van Gogh is as famous for his self-portraits as Rembrandt: they are the two artists we immediately think of when the subject is mentioned. And in Van Gogh's case, these paintings are indeed

least in the sense in which that term is usually understood? At the end of the nineteenth century the dominant movement was Symbolism, and with this many of the artists now described as Post-Impressionists had undoubted links. But some seem more or less free of the basic Symbolist preoccupation with the relationship between external reality, and a quite separate reality which existed within the artist and could be manifested through a selective use and orchestration of certain fragments discovered in the exterior, objective world. Cézanne (1839–1906), who had begun as a kind of forerunner of Expressionism, and who had then, through his friendship with Camille Pissarro, formed links with the Impressionist Movement (he exhibited in the Impressionist exhibitions of 1874 and 1877). In maturity, he became the advocate of an entirely new approach to art. His aim was, he declared, 'to do Poussin over again after nature.' That is, he wanted to abandon the fleeting effects of light favoured by Impressionists such as Monet, while retaining their objectivity and emotional neutrality. Everything became a matter of structural analysis, and when he painted a self-portrait, his own appearance was subjected to the same process. True to his aesthetic credo, he distanced himself from feeling in a way unknown to the other self-portraitists of his time.

just what the legend leads us to expect – personal statements, outcries in paint. Van Gogh shows himself to the spectator completely raw and unprotected, in precisely the way that he exposed himself to his brother Theo in their moving correspondence. As a self-portraitist Van Gogh is astonishingly prolific. During two years in Paris, from March 1886 to 20 February 1888, he painted no less that 22 self-portraits, each a reflection of his circumstances at the particular moment when it was produced. The crisis in Arles, the great turning point of his life, is also recorded in a series of self-portraits, including two showing Van Gogh with his ear bandaged after he had cut part of it off in a fit of frenzy. His expression is very different in each of these portraits. In the earlier, he seems stunned, almost dazed; in the later, where he is shown smoking a pipe, he seems more tranquil, already resigned to the fact that his life has entered its final phase.

Van Gogh's attack of delirium took place on Christmas Eve 1888. In May 1889 he entered the asylum of Saint-Rémy as a voluntary patient. Here, too, he produced self-portraits. One, of September 1889, shows him spiritualised, almost ethereal, with shining blond hair and beard. In May 1890, he moved north, to Auvers-sur-Oise in the Ile-de-France, where he put himself under the care of Dr Paul-Ferdinand Gachet, the friend of many artists, and particularly of members of the avant-garde. The self-portrait Van Gogh produced soon after he arrived at Auvers is different again, powerful and monumental, with a background of whirling paint-strokes. Most authorities on Van Gogh believe that this painting, now in the Louvre, is the artist's final likeness of himself. Those who knew Van Gogh said that it was the portrait which most resembled him.

The powerful legend which gathered round Van Gogh's personality in the years after his suicide, made him seem the very epitome of the modern artist – misunderstood, self-destructive, neglected by his contemporaries. The self-portraits made an important contribution to the myth, and much was read into them. It was inevitably assumed that all self-portraits were now painted for the reasons which seemed to have moved Van Gogh to produce so many – that they were a statement concerning the artist's alienation from society, and an outcry against it.

One artist who seems to fit this pattern is the Norwegian Edvard Munch (1863–1944). The difference is that Munch survived the kind of crisis which destroyed Van Gogh. He had a serious mental breakdown in Copenhagen at the end of 1908, but lived on into old age. The breakdown was nevertheless a turning-point in Munch's life, changing his whole pattern of living. The episode put an end to years of restless wandering throughout Europe, and it turned Munch into a teetotaller (he had previously been a heavy drinker). But the parallels are not as close as they seem at first. Munch was an early, rather than a late starter, and was already an accomplished painter before he became a truly original

one; something that is demonstrated by several of his earliest self-portraits. Though he visited France as a young man, he did not strike roots there; his first major successes came to him in Germany, and his paintings also show much closer links to literary Symbolism than can be detected in those of either Gauguin or Van Gogh. This is confirmed by the imagery used in several of the self-portraits of his early maturity.

A well-known example of 1895, *Self-Portrait with Burning Cigarette* (Oslo, National Gallery), shows the artist as a well-dressed *flâneur*; the theatrical lighting suggests that this is Munch as Mephistopheles, manipulator rather than victim, deliberately concealing as much as he reveals. *Self-Portrait with Wine Bottle* of 1906 (Oslo, Munch Museum), is more candid. It shows us a man who is clearly deeply depressed, sitting alone at a table in an almost deserted restaurant. But even this, for all its candour, differs from Van Gogh's self-portraits in one very important way. Van Gogh never places himself in a specific context or situation as Munch does here; his own features are enough for him, they seem to present him with a puzzle which he can never completely solve. In *Self-Portrait with Wine Bottle* Munch guides the spectator towards an interpretation and therefore a solution – he does it by using a specific setting and equally specific accessories. Many of the most important paintings produced before his breakdown are fragments of a personal narrative, such as *Jealousy*, of 1895, which incorporates a portrait of the unstable Polish author Stanislaw Przybyzewski, whose wife Munch was then in love with. Even the paintings of the *Frieze of Life*, which are supposedly statements about the general human condition, contain autobiographical allusions. Van Gogh sometimes depicted himself emblematically – *Van Gogh's Chair* in the Tate Gallery is the most famous example of this – but the separation between artist and artifact is clearer than it is in Munch. The latter used an apparent objective correlative, a specific 'subject', chiefly as a way of conveying a state of mind. *The Scream* of 1893 is a good instance of this. The artist has left a description of how the image came to him: 'One evening I was walking along a path, the city was on one side and the fjord below. I felt tired and ill. I stopped and looked out over the fjord – the sun was setting and the clouds turning blood-red. I sensed a scream passing through nature; it seemed to me that I heard the scream. I painted this picture, painted the clouds as actual blood. The colour shrieked. This became *The Scream* of the *Frieze of Life*.'

After Munch's recovery from his breakdown, his work altered in harmony with the change in his whole pattern of living. The new compositions (he also made new versions of old ones) are now often Norwegian landscapes, or interpretations of the everyday world of work – men shovelling snow; a man ploughing. The allegories, where they occur, as for instance, in Munch's murals for the Oslo University Aula, are more obvious, less entangled

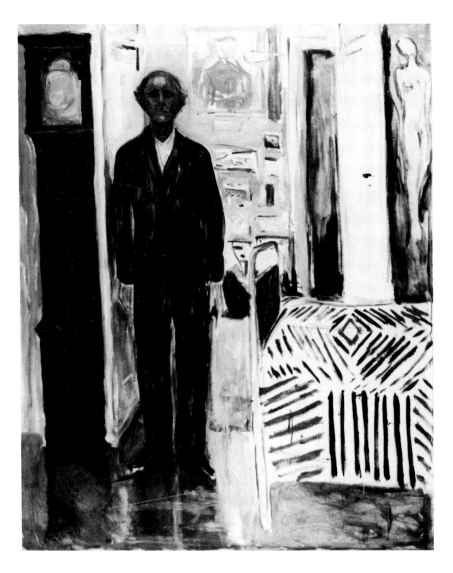

Edvard Munch, *Between Clock and Bed*, 1940–42. Munch Museum, Oslo

with the skeins of the artist's own life and personality. The self-portraits, which he continued to paint in some numbers, now occupy an important but quite separate place. Often they give vent to feelings of loneliness and depression which no longer manifest themselves elsewhere, as in *The Night Wanderer* of 1939. The self-portraits painted in Munch's final decade reflect on human mortality and the passing of time, sometimes with bitterness, sometimes with irony. The bitterness is dominant in *Between Clock and Bed* of 1940 – the title sums up both the imagery and the theme. Irony is predominant in *Cod Lunch* of the same year. Here the artist raises his knife and fork to tackle an old-Norwegian delicacy, a whole cod's head, which sitting on its plate, assumes the traditional role of the human skull as a *momento mori*.

Munch's late self-portraits prompt a comparison not with Van Gogh but with Pierre Bonnard (1867–1947). Bonnard's early career was less turbulent than that of Munch, but they followed a rather similar pattern; both deliberately withdrew and spent their final decades in retirement, painting actively but no longer participating in the busy international art world they had once frequented. Bonnard's self-portraits occur intermittently throughout his career but the most significant belong to his final decades.

As Steven A. Nash points out in an essay written for the catalogue of the show of Bonnard's late paintings held in Washington and Dallas in 1984, there had been Munchian elements in Bonnard's work long before this, and these were reinforced when Bonnard came into direct contact with German Expressionism on a trip to Hamburg in 1913. But these influences took a long time to resolve themselves, indeed they do not fully do so until the final two decades of Bonnard's career. The most startling of his self-portraits, and the most Expressionistic, is *The Boxer* of 1931 which shows a skinny, bare-chested Bonnard clumsily sparring with his own reflection. He seems to be engaged in a hopeless and pathetic battle against the ravages of age, which are already clearly apparent in both face and body. Other self-portraits dated 1939 and 1945 (there are three from the latter year) show the artist continuing this pessimistic struggle, and finally admitting defeat.

Another artist, slightly younger than either Munch or Bonnard, who was possessed by the idea of death from a much earlier age than they, was Paula Modersohn-Becker (1876–1907). By 1900, though apparently in perfect health, she was already convinced that she would not live long. Her premonition was correct: she died as the result of an embolism, less than three weeks after the birth of her daughter Mathilde. Modersohn-Becker was the most powerful and original female artist of the period which witnessed the transition to Modernism. Her work anticipates that of the German Expressionists, and though she did meet Emil Nolde in Paris in 1900 she had little contact with them. Her chief influences came directly from French Post-Impressionism; from Gauguin and Van Gogh in particular.

Modersohn-Becker's life was a constant struggle to find a role, a solution to the dilemma of the woman artist who was also a modernist. Her parents, though cultivated and not unsympathetic to her artistic ambitions, only allowed her to go to art school (the Berlin Art School for Women) if she also trained to be a teacher. She first experienced the social and artistic freedom she craved on a holiday visit to Worpswede, an artists' colony in a remote village north of Bremen. Here she came into contact with other women artists who shared her ideas. She also met Otto Modersohn, the painter who was to become her husband. She seems to have decided to marry him after a visit to Paris in 1900; she felt an urgent need to go back there and absorb all she could. Marriage offered the possibility of escape from her family, and Modersohn tolerated, if rather grudgingly, her long absences in France. It was not until the early spring of 1907 that Paula agreed, finally, to settle down with him in Worpswede. Almost immediately she became pregnant; the child was born on the 2 November that year. Less than three weeks later she was dead.

Modersohn-Becker was well aware of the nascent women's movement of her time, but expressed

reservations about it. Her view was broader – the self-portraits which make up an important segment of her total *oeuvre* represent a search for female identity, but one which would escape from feminist clichés. The most striking of these portraits show Modersohn-Becker semi-nude, for example the *Self-Portrait on her Sixth Wedding Day*, in which she also seems to be pregnant. The picture, however, was painted in 1906, and thus antedates her actual pregnancy. In this, and indeed in the majority of her self-portraits, there is strikingly little effort to render character. Modersohn-Becker seems instead to be searching for some essence, some universal element which will make visible an entire female cosmos, till then hidden. Her impersonal presentation of her own likeness is one of her main points of difference from her Expressionist successors in Germany.

These, in any case, took their inspiration from a different range of sources. They were aware of Gauguin and the other Post-Impressionists but were far more excited by the Fauves, and especially the work of Matisse, whose success was more rapid in Germany than it was in his own country. In addition, they owed much to Munch. One of Munch's chief attractions to them was the fact that he was, like themselves, northern European. The consciousness that they were in some fundamental way northern made the Expressionists look back for all their determination to revolutionise art, to the Late Gothic of artists such as Grünewald, whose *angst* seemed to match their own. They also saw themselves as the heirs of Dürer, with his acceptance of a doctrine of personal responsibility. For the Expressionist artist, the self-portrait was almost too easy a vehicle, it allowed him every opportunity to parade his own subjectivity. It is perhaps for this reason that many of the most satisfactory images created under the aegis of Expressionism are the creation of artists whose work is not absolutely central to the movement. In Vienna, where Expressionism was diluted with other elements, many of them, such as the discoveries of Freud, extra-artistic, brilliant self-portraits were painted by members of the Vienna Secession: by Oskar Kokoschka (1886–1980), Egon Schiele (1890–1918) and Richard Gerstl (1883–1908) in particular.

Gerstl, the oldest of the three, was also the shortest lived; he committed suicide at the age of 25, an early victim of twentieth-century feelings of alienation. His self-portraits are an important part of his surviving output (he destroyed as many paintings and drawings as he could before he killed himself). Often he shows himself grimacing, giving vent to a mirthless laugh. Some of his self-portraits have a superficial likeness to those of an eighteenth-century compatriot, the sculptor Franz Xaver Messerschmidt. But Messerschmidt's intention, in recording various grimaces, seems to be naively experimental – which conformation of the facial muscles can be said to correspond with a particular emotion? In Gerstl one detects a desperate appeal to the spectator to look behind the mask.

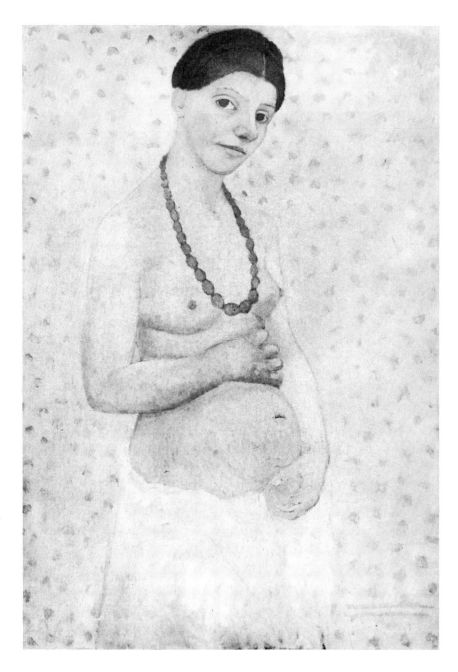

Kokoschka was a more confident personality than Gerstl, but in his self-portraits, too, there is a histrionic element. He acts out different roles, but what is happening in the paintings is more complex than similar play-acting in the work of Courbet. Kokoschhka's *Bride of the Wind* (1914), the most powerful picture he ever painted, celebrates his passionate but deeply uneasy relationship with Alma Mahler, the voluptuous widow of the composer. The two floating figures are recognisably those of the artist and his mistress, but they are mythologised, turned into beings whose love makes them more than mortal – they are Paolo and Francesca in Dante's *Inferno*, condemned to float forever in the fiery whirlwind. The mundane truth was a little different as Kokoschka's relationship with Alma did not survive the outbreak of war.

Perhaps the most interesting of the three artists, and also the most disconcerting, is Egon Schiele, whose reputation has, in recent years, considerably outstripped Kokoschka's. In Schiele's work, self-

Paula Modersohn-Becker, *Self-Portrait on her Sixth Wedding Day*, 1906. Ludwig Roselius-Sammlung, Bremen

revelation is an act of aggression. The personality revealed by his biographers, though fascinating, is also unattractive, and everything they tell us is confirmed by the artistic legacy. Schiele was self-centred, self-pitying, profoundly narcissistic. His numerous self-portraits show him continually strutting and posing. He pulls down the flesh of his cheek so as to distort his features; he reacts to a brief imprisonment with melodramatic attitudinising: he even, in one drawing, shows himself masturbating. What turns these paintings and drawings into superb works of art is their note of desperation. Schiele can never quite break open the carapace which confronts him in the mirror so as to reveal his true self to the spectator. One may ask why it was so important to him to make this revelation? the answer is very simple: Schiele represents a crucial stage in the development of the Western European tradition of visual art – the point at which the artist's real subject becomes himself; where every work he creates, whatever its ostensible theme, is primarily an act of self-revelation and also of self-recognition.

Schiele died in the great Spanish influenza epidemic of 1918, and his death marks a watershed in the long history of the self-portrait. Ostensibly there were many reasons why the genre should have flourished in the interwar period as never before: there was the creation of a new consciousness as Freud's teachings penetrated the intellectual culture of Europe and North America, in addition to the increasingly self-referential nature of the artist's own activity. But none of this prevailed against the idea (widespread everywhere except among the German painters of the Neue Sachlichkeit) that the making of portraits was somehow an un-modern or even anti-modern activity.

It is too much of a simplification to see this as forming part of the battle between figuration and abstraction. Some committed modernists did continue to make the depiction of reality, and in particular of the human figure, the basis of their activity. One such was the Russian-born and Paris-domiciled Expressionist Chaim Soutine (1893–1943), whose *oeuvre* offers a preponderance of portraits over all other subjects, and thus seems to go clean against the prevailing current of its time. But Soutine used portraiture as a kind of pretext; he wanted to rip some secret essence from his sitters, and by looking at them, to look at himself – but timorously and obliquely, like Perseus gazing at Medusa in his shield. Clearly, Soutine was not comfortable with his own image: his self-portraits are very few for such a prolific artist, and have a tentative quality which is alien to the rest of his work.

The most important self-portraits of the inter-war period were painted by artists who were not at the centre of events. Some, like Bonnard and Munch were old and eminent, and had drifted away to quiet backwaters, far from the centres of artistic activity. Others, like the German Max Beckmann (1884–1950), perhaps the most prolific self-portraitist of his

time, and the Englishman Stanley Spencer (1891–1959) were not only temperamentally isolated from the major art movements of the time, but were also affiliated to peripheral schools of art. Spencer's startling nude self-portraits, sometimes with his second wife Patricia Preece (their relationship in fact was notoriously unsuccessful) are a naively candid expression of his sexual fantasies, Beckmann's self-portraits express a greater range of feeling, and more complex social relationships. Before the First World War the young Beckmann made a very rapid success as an artist. He was patronised by Count Harry Kessler, one of the greatest German collectors of the time, and showed with the major dealer Paul Cassirer. He was, however, severely shocked by his experiences in the First World War, and was invalided out of the Germany army with a nervous breakdown. His collapse prompted him to begin his life completely afresh. The wartime self-portraits and those painted in the period which immediately followed show the marks of the experiences he had passed through, but as the 'new' Beckmann matured, he seemed to want to present himself in a different way, as a burly anglophile businessman, in a well cut suit or even a dinnerjacket, muscular, slightly aggressive – the self-portrait, in Beckmann's hands, takes on the guise of a self-protective mask.

But occasionally the self-portrait survived, not as a means of self-appraisal or self-examination, but as a means of creating a myth. In the work of Marc Chagall (1887–1985) the often repeated figures of lovers stand for Chagall and his first wife Bella. But only rarely, as for example in the *Double Portrait with Glass of Wine* of 1917–18 in the centre George Pompidou, is there any attempt to make a likeness. Even here, the faces are conventionalised. The similar epiphanies of married love painted by the contemporary British artist Anthony Green, are much more particularised.

Narrative self-portraiture, the notion of the artist as an actor in his own play, is something which reaches back beyond Chagall to Toulouse-Lautrec, though Lautrec did not flatter himself like Chagall but took an extremely sardonic view of his own dwarfish appearance. Lautrec's most obvious successor is Picasso (1881–1973). Picasso began his career as a very evident disciple of Lautrec and continues to show intermittent signs of his influence. It is sometimes said that Picasso, after making a few early attempts at the genre, abandoned the self-portrait very early, that there is nothing of this sort which post-dates the invention of Cubism. This is true of the paintings and sculptures, but can be disputed in the case of Picasso's prints and drawings. The prints of the Vollard Suite, which date from the mid-thirties, turn 'the artist' into a mythic personage, triumphant creator and equally triumphant lover. But this artist, bearded and leonine, is a type, and his appearance has no resemblance to Picasso himself. The situation is different when we come to the drawings made for the magazine *Verve* in the 1950s, and the great suite of no less than 347 prints

created in 1968. As he grew older, Picasso became increasingly obsessed by the physical indignities inflicted by age. In the *Verve* drawings, a putto playfully threatens a beautiful young woman with a grotesque mask which is in fact a self-caricature of the already aged Picasso. In the print series of 1968, the self-mockery has become more bitter. In one design (no. 319), Picasso portrays himself as a wizened voyeur wearing a jester's hat, who peers morosely at the enthusiastic love-making of a handsome young artist and his model. When the prints were first published Picasso's legend was so powerful that both the critics and the rest of his audience were reluctant to acknowledge the obvious meaning of some of the images.

But Picasso was by this time a survivor from another age, and his juniors were reluctant to be so specific. The paintings of the leading Abstract Expressionists, particularly those of Jackson Pollock (1912–56) and Mark Rothko (1903–70), are generally interpreted as autobiographical outpourings, and in this sense could be regarded as metaphorical self-portraits. To some extent, this interpretation was encouraged by the artists themselves. Yet Rothko, for instance, once told an interviewer that he was 'interested only in expressing basic human emotions – tragedy, ecstacy, doom and so on.' He added: 'the fact that a lot of people break down and cry when confronted with my pictures shows that I can communicate these basic human emotions . . . The people who weep before my pictures are having the same religious experience as I had when I painted them.' There is something extremely dubious about all this, a whoring after romantic sublimity which is not perhaps inherently present in the work – but Rothko's remarks do at least make it clear that the paintings move very swiftly from purely personal states to more generalised emotions which can be shared collectively in this sense, they are not an act of self-portrayal.

The case of Andy Warhol (1930–87) is very different. Warhol practised a cool indifference to emotion which contained an implied rebuke to the lachrymose extravagancies of his Abstract Expressionist predecessors. As a painter, he was above all a creator of icons for the consumer society, and the human face was one of his favourite subjects. Long series were devoted to popular demi-gods like Marilyn Monroe, Elvis Presley and Jacqueline Kennedy. These images were bound up with Warhol's cult of fame; and the likenesses, simplified by the artfully crude use of silk-screen, are just sufficiently recognisable to trigger a series of stock reactions to the particular reputation involved. Starting from a photograph, Warhol manipulated the image so as to remove any residuum of the personal. His own self-portraits, treated in precisely the same way, imply that Warhol himself has now achieved the mythic isolation of his chosen idols. In Warhol's hands, the self-portrait conceals rather than reveals, and does so with more efficiency that the later likenesses of Max Beckmann.

Andy Warhol, *Self-Portrait*, 1967. Saatchi Collection, London

Warhol's brand of Pop Art is very different from other kinds of art that go under the same label. David Hockney (1937–) and Peter Blake (1932–), intimately connected with the rise of the Pop Art movement in England, have certainly used self-portraiture in a diametrically opposite sense – that is, they have employed it for purposes of self-revelation in a fashion which stresses the link between their work and that of Stanley Spencer. In general, this seems to be the course which self-portraiture is taking today, especially in Britain. The images reproduced in this book demonstrate that the making of self-portraits is in the throes of a vigorous revival, that this is an activity which now interests many artists, of very different persuasions.

Why, in fact, should this be so? I can think of a number of reasons. First, figuration is once again the dominant mode. Secondly, portraiture has lost its stigma, as the divide between avant-garde and academic spheres of activity has become less marked. Third, the artist's basic subject continues to be himself. There is still no common ground of subject-matter concerning which objective statements can be made. Every artist has to invent his own myth, and it seems inevitable that he or she should feature prominently as a personage within it. Lastly, I think that artists have become increasingly worried that they are cutting themselves off from the full riches of the Western European tradition. They are not ready to renounce modernism, but can no longer accept the notion that they must be exclusively loyal to it. The plurality of styles, so often commented upon by critics during the 1970s, has become a genuine plurality of aesthetic attitudes. The contemporary self-portrait often seems to have a very special significance in this respect; it reaffirms the artist's right to link his own work to that of the great masters of the past. This introductory essay has been designed to try and provide at least a glimpse of the riches offered by art-history in this respect, and their direct relevance to what artists are creating today.

BIBLIOGRAPHY

Manuel Gasser, *Self-Portraits: from the Fifteenth Century to the Present Day*, Weidenfeld and Nicolson, London, 1963

Ludwig Goldscheider, *Five Hundred Self-Portraits*, George Allen & Unwin, London, 1937

Joan Kinneir, *The Artist by Himself; self-portrait drawings from youth to old age*, Granada Publishing, London, 1980

Michelangelo Masciotta, *Autoritratti dal XIV° al XX° Secolo*, Electa Edirice, Milan, 1955

Dr. Fritz Ried, *Das Selbstbildnis*, Die Buchmeinde, Berlin, 1931

SELF-PORTRAITS FOR AN EXHIBITION

EDWARD LUCIE-SMITH

Many of the paintings, drawings and sculptures included in the exhibition which this book accompanies have been created especially for the occasion. A large proportion is the work of artists who have never previously attempted the self-portrait genre. The collection offers a cross-section of the different styles of art being practised in Britain today, and at the same time it demonstrates the possibilities and perhaps also the limitations of the modern self-portrait.

It may come as a surprise to find how many of the images invite the adjective 'realistic'. There is a high proportion of immediately recognisable likenesses. Those already acquainted with the artists concerned will have no difficulty in recognising them. This applies even with artists not usually categorised as realists. Anthony Caro's powerful self-portrait drawing, for example, will come as a surprise to his admirers; and so too, perhaps, will the delicate self-portrait by Barry Flanagan. There are a number of other cases in point, among them the penetrating self-portrait by Ken Kiff.

Yet, though many of the works are easily recognisable likenesses, the artists are not usually concerned with their role in society, and in this they differ from a large part of the established tradition of self-portraiture. The mood is nearly always introspective, and occasionally it seems more than a little sombre. One of the most moving of the realistic likenesses is the painting by Harry Holland.

When compared with an earlier self-portrait by the same hand, this picture seems markedly more introspective, filled with an awareness of the inexorable passage of time. In theory an image of this kind brings time to a halt, just as a photograph does, but in reality it is filled with the threatening echo of time's passage. Equally introspective in mood is the painting by Michael Leonard, which portrays the artist in extreme close-up, staring directly at the spectator, but nevertheless seemingly abstracted and unaware of their presence.

Leonard's self-portrait, with its deliberate modesty, makes a striking contrast with another head that stares directly at us – the heroic, over-lifesize self-portrait by Peter Howson, who here presents the creative artist as a hero-figure. Howson's work has often been compared with that of the German artists of the *Neue Sachlichkeit*, and particularly with Grosz and Dix, but here the more obvious comparison is with the Mexican muralists, most of all Orozco and Siqueiros. The painting, un-like the rest, is a public statement about cultural and social struggle, and the artist's central role in it.

On the other hand, Peter Prendergast's painting, though executed in an equally forceful technique, hints at a very different view of the artist's situation. The heavy shadow which partly obscures the features suggests withdrawal and uncertainty. It prompts a comparison with the early self-portraits of Rembrandt, which make use of the same device.

Many of the self-portraits included in the show use traditional devices to tell us that we are in the presence of an artist. Behind Leonard McComb's head is one of his own drawings on an easel; Anthony Green holds a just-visible palette; Jock McFayden and Patrick Procktor are seen in the act of painting; William Wilkins is working in the presence of a nude model. The two last-mentioned works both incorporate a mirror as part of the composition, and this appears in other paintings as well – Timothy Hyman's painting is itself a feigned convex glass (harking back to the celebrated youthful self-portrait by Parmigianino), and Norman Blamey offers a dazzlingly accomplished exercise in *trompe l'oeil*, perhaps intended as a reminder that the artist's view of himself – his own character as well as his appearance – is always, and necessarily, an illusion.

Quite a number of the artists here offer overt, or covert, references to the art of the past. One of the subtlest occurs in the drawing by Flanagan, which has a haunting echo of Manet in both style and approach. It was indeed drawn immediately after seeing Manet's *La Musique aux Tuileries* for the first time. R. B. Kitaj's self-portrait drawing also seems to allude to earlier models, but in a very indirect way. Perhaps its original inspiration was the Durer drawing in which the artist shades and circles his eye with his fingers.

In other works the references are more specific. Alan Stones stares out at us against the background of Giovanni Bellini's *St Francis in Ecstasy* in the Frick Collection, New York. John Bellany includes both a Van Gogh self-portrait and the punning signature 'Giovanni Bellini'. Keir Smith's drawing alludes to the sculpted portraits of Alexander the Great; while Stephen McKenna, while not apparently making reference to any one artwork, invites us to think of the French seventeenth century *maîtres de la réalité*, and maybe specifically of the still-life painter Sebastien Stoskopff.

Not surprisingly, a number of the portraits include surrealist, or at any rate allegorical ele-

ments. The most extreme example is Glen Baxter's contribution, not recognisable as a portrait, much less as a self-portrait, when separated from the context the exhibition provides. John Kirby, in a memorable image, depicts himself in women's dress, one hand raised in a saintly gesture of blessing. The painting explores personal conflicts concerning religion (he was brought up as a Catholic), and the idea of gender.

Some of the most powerful of these allegorical representations come from women. Rose Garrard, gun in hand, parts her garment to give birth to her own likeness. The lower part of her drapery half-conceals a whole arsenal of other weapons. Amanda Faulkner also uses a double image – the main figure embraces a second, more simplified and radical likeness. Lys Hansen mimes her desire to run away from the self-confrontation of making a self-portrait – the painted head sprouts clutching hands which seek to conceal it. Eileen Cooper is more confident about self-exposure. She depicts herself as a nude figure in a boat, that is alive with wriggling fish.

One of the most remarkable features of the show is the presence, not only of self-portrait drawings by sculptors, but of actual sculpted self-portraits. Since the Middle Ages, self-portraits in three dimen-sions have been very rare. It is worth asking why this should be the case. The reason seems to be chiefly technical. The painter, looking at himself in a mirror, can treat the glass as an equivalent for the canvas, and try to reproduce upon one surface what he seems to see on another. The things he does not see concern him only a little, though he may be concerned to give his forms a sense of volume. The case of the sculptor is very different – he has to try to imagine the whole volume of the head, that is, if he is concerned to reproduce it in any way realistically. A notable example of the struggle to resolve these difficulties is the self-portrait bust by Glynn Williams. Other three-dimensional self-portraits are less interested in realism and more concerned with symbolism. Some are notably violent – Roger Moss and Malcolm Poynter seem to show the body already in decay; Mandy Havers presents herself flayed – skin peeled back to show the muscles and tissues beneath.

Whatever the verdict on individual works – and to my eye this is a collection of unusually high over-all quality – it seems likely that this book and exhibition will spark a renewed interest in a perennially fascinating subject, and a lively debate about the essential qualities of the contemporary self-portrait.

THE ARTISTS

DAVID HOCKNEY

Born Bradford, 1937. Studied at Bradford College of Art 1953–57 and the Royal College of Art 1959–62. Between 1963 and 1967 held lecturing positions in America at the Universities of California, Iowa and Colorado. Held his first one-man exhibition in London in 1963. Since that time has been the subject of one-man exhibitions in Great Britain, the United States of America, Holland, Belgium, Italy, Germany, France, Canada, Austria, Switzerland, Australia, Japan, Sweden, Portugal, Spain, Israel, Finland and New Zealand. Hockney's work encompasses several different media including painting, drawing, print-making, design for the stage, photography, photo-collages and, most recently, working with Xerox colour printing. Has lived and worked predominantly in Los Angeles since 1979. Elected R.A. in 1986.

David Hockney
Self-Portrait 1978
$16\frac{1}{2} \times 13\frac{1}{2}$in, $41\cdot9 \times 34\cdot2$cm
Ink drawing

SIDNEY B FELSEN

31

HARRY HOLLAND

ANTHONY LYSYCIA

Harry Holland
Self-Portrait
32 × 24in, 81·2 × 61cm
Oil on panel

Born in Glasgow, 1941. Studied at St Martin's School of Art, 1965–69. He held his first one-man exhibition in Nottingham in 1979, and has since held six one-man shows in London, plus others in Edinburgh, Bath, Henley and Brussels. In 1980 he was the subject of a Welsh Arts Council touring show. He paints full-time, and lives and works in Cardiff.

TOM PHILLIPS

Born in London, 1937. Studied at St Catherine's College, Oxford and the Camberwell School of Art, London. First one-man exhibition, London, 1970. Has since held retrospective exhibitions at The Hague and in Basle, and (1976) at the Serpentine Gallery in London. Publication of the first pages from *A Humument*, based on W.H. Mallock's *A Human Document*, 1965. *A Humument* was published in 1980 by Thames & Hudson, London; and this was followed in 1983 by the publication of an edition of Dante's *Inferno*, translated, and designed, as well as illustrated by the artist. Tom Phillips is also a com-

Tom Phillips
Self-Portrait at 50
$5\frac{3}{4} \times 3\frac{5}{8}$in, 14·2 × 9·2cm
Ink and gouache on bookpage

poser. His opera *Irma* was premiered at York University in 1973, and his first record, *Words and Music*, was issued in 1974. He is currently working with the film director Peter Greenaway on a series of television programmes for Channel 4 based on Dante's *Inferno*, and is starting work on a new translation, from the Anglo-Saxon of, and illustrations to, *The Seafarer*.

Angela Flowers Gallery, London

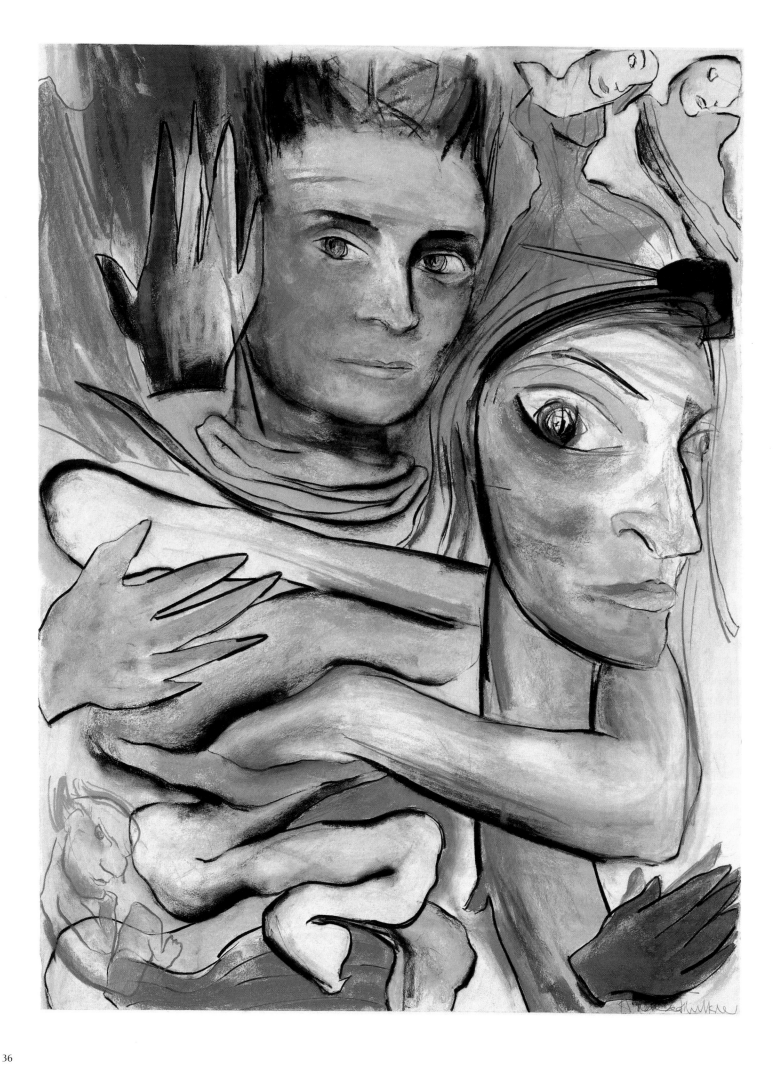

AMANDA FAULKNER

Studied at Bournemouth College of Art and Design, 1978–79; at Ravensbourne College of Art and Design, 1979–82; and at Chelsea School of Art, 1982. Held her first one-woman exhibition in London in 1983, and has since had two more one-woman shows in London. Lives and works in Stoke Newington.

Amanda Faulkner
Self-Portrait
$41\frac{3}{8} \times 31$in, $105 \times 78\cdot8$cm
Conte crayon on paper

ISABELLE BLONDIAU

Angela Flowers Gallery, London

STEPHEN McKENNA

Stephen McKenna
Self-Portrait
32 × 24in, 81·2 × 61cm
Oil on canvas

Born in London, 1939. Studied at the Slade School of Art, 1959–64. Lived in Bonn, West Germany, from 1971–78. He has held one-man exhibitions in London, Frankfurt, Munich, Brussels, Antwerp, Berlin, Oxford, Dusseldorf, Eindhoven and Milan, among other places. In 1982 he exhibited in Documenta 7, Kassel; and in 1987 in 'Avant-Garde in the Eighties' at the Los Angeles County Museum. He currently lives and works in Brussels, London and Co. Donegal, Eire.

Edward Totah Gallery, London

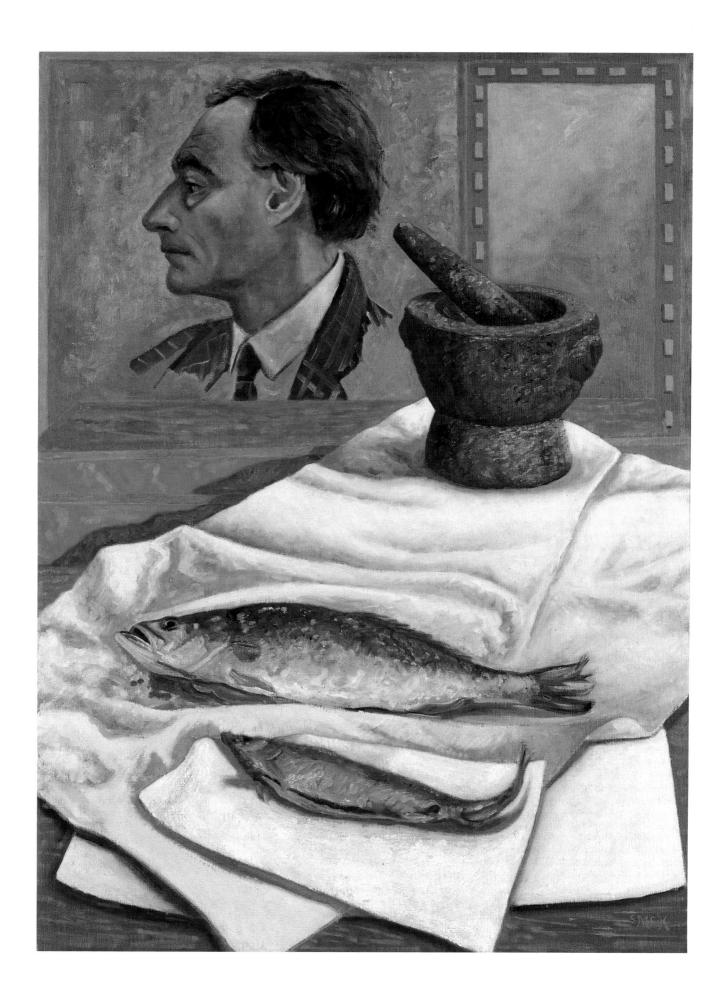

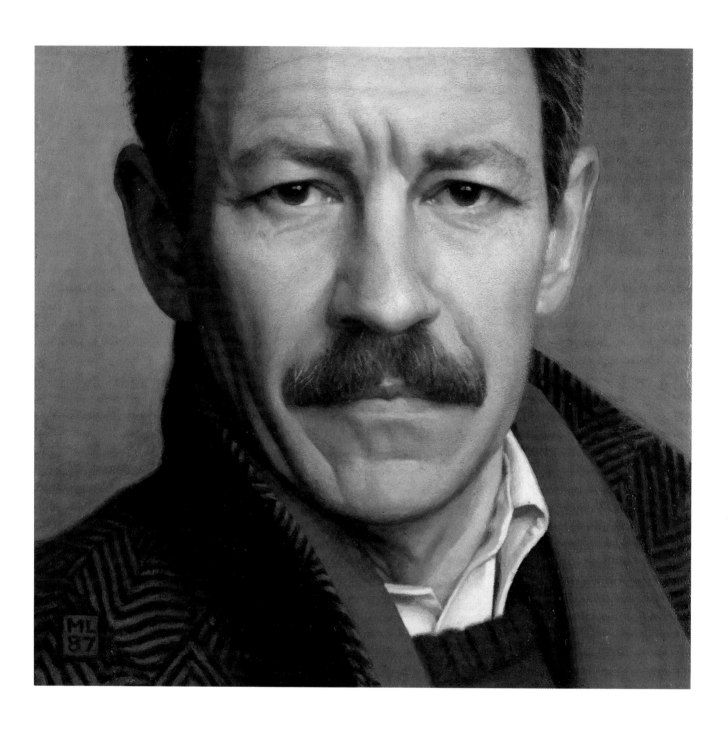

MICHAEL LEONARD

VIV LAWRENCE

Michael Leonard
Self-Portrait
$9 \times 9\frac{1}{2}$in, $22\cdot9 \times 24\cdot2$cm
Alkyd on masonite

Born in Bangalore, India, 1933. Studied Graphic
Design and Illustration at St Martin's School of Art
in 1954–57. From 1957 worked as a freelance illustra-
tor. In 1969 began to devote progressively more time
to painting, and over the next few years gradually
relinquished illustration to work full time as a pain-
ter. His first one-man exhibition was held in London
in 1974. He has since held three more one-man
exhibitions in London, and another is planned for
October 1988. There have been one-man exhibitions
in New York and at the Gemmente Museum, Arn-
hem. In May 1986 his portrait of H.M. the Queen
was presented to the National Portrait Gallery by
Readers Digest.

Fischer Fine Art, London

GLEN BAXTER

Born in Leeds, 1944. Studied at Leeds College of Art, 1960–65. Taught at the Victoria & Albert Museum, 1967–74, and was part-time lecturer in fine art at Goldsmiths College, London, 1974–86. Held his first one-man exhibition in New York in 1974, and has since held one-man exhibitions in Venice, Cardiff, Bradford, Aberdeen and San Francisco. Is also well-known for art-works published as books. Lives and works in London.

Glen Baxter
Self-Portrait 1987
$24\frac{3}{8} \times 23\frac{1}{4}$in, 62×59cm
Oil and gold leaf on canvas

Nigel Greenwood Gallery, London

NICK GEORGHIOU

Glynn Williams
Self-Portrait
$19\frac{1}{4} \times 16\frac{1}{2} \times 12\frac{1}{2}$in,
$48\cdot9 \times 41\cdot9 \times 31\cdot7$cm
Weatherbed Ancaster stone

GLYNN WILLIAMS

Born Shrewsbury, 1939. Studied at Wolverhampton College of Art, 1955–60, plus a post-diploma year in 1960–61. Awarded the Rome Scholarship in Sculpture, 1961, and lived and worked at the British School in Rome, 1961–63. Is at present head of the sculpture department at Wimbledon School of Art, and lives and works in London. His first one-man exhibition was held at the I.C.A., London, 1967. Since then he has had a number of one-man exhibitions in London, Hull, Sheffield, Leeds, Wakefield, Cardiff and in 1987 at Artsite in Bath. Commissions include a prize-winning sculpture sited permanently at Utsukushi-ga-hara Open Air Museum, Japan.

Bernard Jacobson Gallery, London

ALAN STONES

Born in Manchester, 1947. Studied at St Martin's School of Art, 1967–71. Lived as a self-employed artist in Thetford, Norfolk, 1971–82, then moved to Blencairn, Penrith, Cumberland. Held his first one-man exhibition in 1984 at Wetheriggs, Clifton Dykes, Penrith. Since then has had several one-man exhibitions in Kendal, Oldham, Doncaster, Grasmere, Thetford, Peterborough, King's Lynn, Colchester, Preston, Carlisle, London, Ilkley, Hawick, Sheffield and Ayr. His most recent one-man exhibition toured the Scottish Highlands Region.

Alan Stones
Self-Portrait
$21\frac{7}{8} \times 17\frac{1}{4}$in, 55·6 × 43·7cm
Oil on canvas

GAVIN YOUNG

STEPHEN BARCLAY

Born in Ayrshire 1961. Studied at Glasgow School of Art 1980–85, was awarded an Adam Bruce Thomson Award from the Royal Scottish Academy in 1984. Included in the 'New Image: Glasgow' exhibition which toured Great Britain in 1985; first one-man exhibition held in London 1987. Lives and works in Scotland.

Stephen Barclay
Self-Portrait
28½ × 20½in, 72·3 × 52cm
Gouache on paper

HARPERS & QUEEN

Graham Paton Gallery, London

KEN KIFF

Born Essex 1935. Studied at Hornsey School of Art 1955–61. Taught part-time in schools and subsequently lectured at Chelsea School of Art and the Royal College of Art. In 1977 illustrated *Folk Tales of the British Isles*. Attended the Artists Camp at Kasauli, North India, 1981. Held his first one-man exhibition in Sussex in 1979, has since had one-man exhibitions in Edinburgh, Stirling, Dundee, Bristol, London and New York. Lives and works in London.

Ken Kiff
Self-Portrait 1987
$30\frac{1}{2} \times 22$in, $76\cdot9 \times 55\cdot9$cm
Charcoal on paper

Fischer Fine Art, London

Ken Raff 1987

NORMAN BLAMEY

Born in London, 1914. Studied at Regent Street Polytechnic, London, 1931–37, and taught there 1938–40. Served in the army 1941–46, before returning to teach at the Polytechnic, 1946–63. Senior Lecturer at the Chelsea School of Art, 1963–79. Elected A.R.A. 1970; R.A. 1975. Visitor at the Ruskin School of Drawing and Fine Art, Oxford, 1978–80. Has exhibited regularly at the R.A. Summer Exhibitions since 1958, and had a major retrospective at the Round House, London, in 1980.

Norman Blamey
**Self-Portrait
in Cushion Mirror, 1987**
36 × 28in, 91·4 × 71·1cm
Oil on board

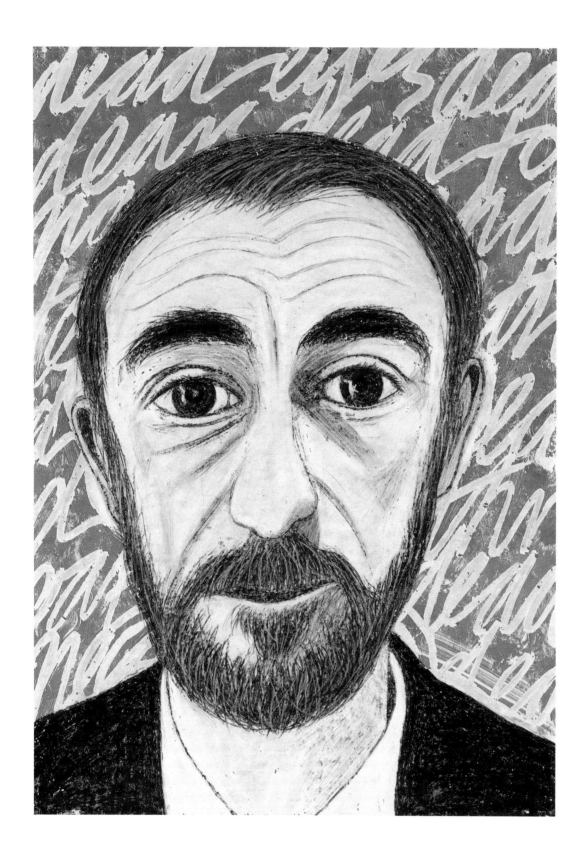

IAN BREAKWELL

Born in Derby, 1943. held his first one-man exhibition in London in 1970, and has since had one-man shows in Nottingham, Paris, Edinburgh, Glasgow, Cardiff, Cambridge and Madrid. Has made six films, beginning with *Growth* in 1969, plus a number of videos – the most recent being a series of eight programmes transmitted by Channel 4 in 1984. He has also published eight books, the majority being extracts from his *Diary*, which was published in a single volume for the years 1964–85 in 1986, by Pluto Press, London.

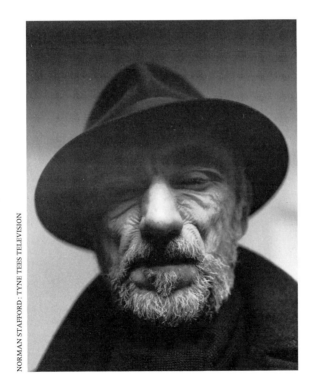

NORMAN STAFFORD : TYNE TEES TELEVISION

Ian Breakwell
Self-Portrait 1986
25 × 17¾in, 63 × 45cm
Oil and wax on paper

Anthony Reynolds Gallery, London

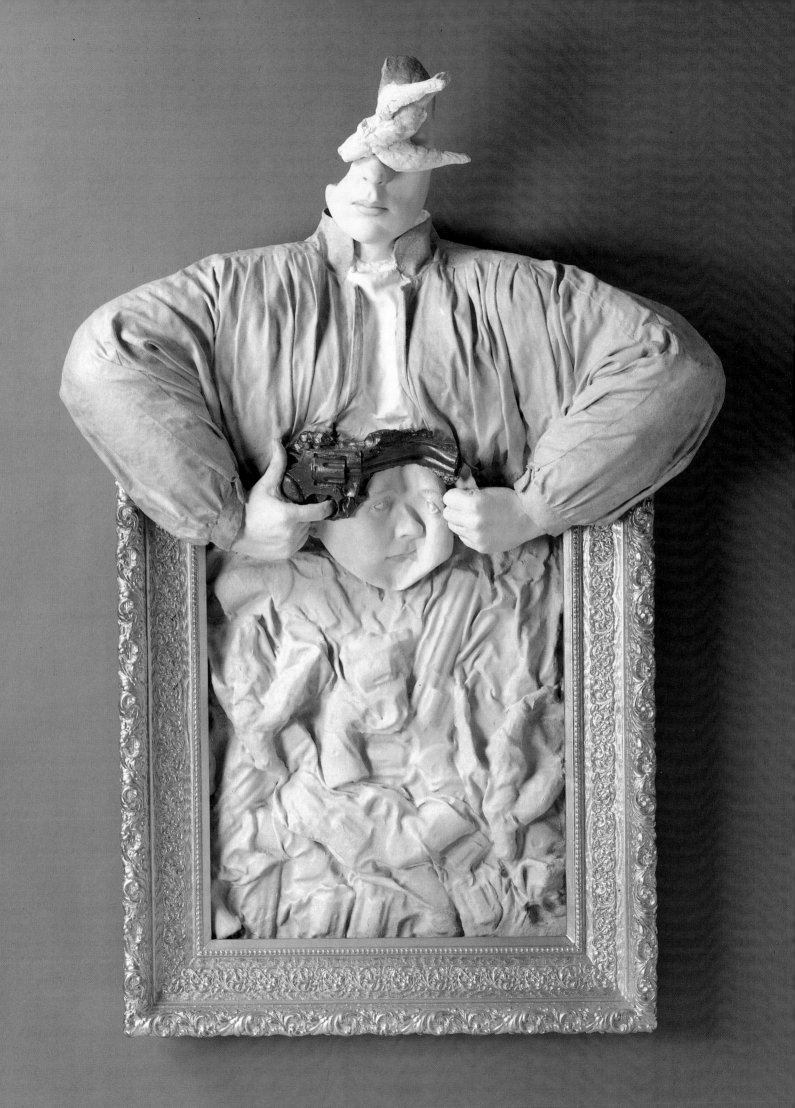

ROSE GARRARD

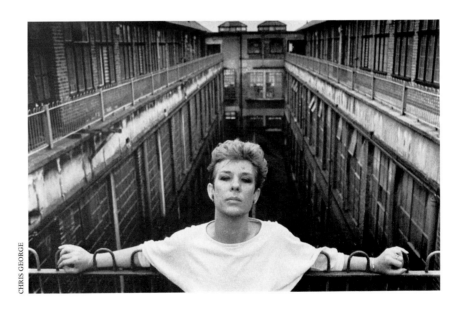

CHRIS GEORGE

Rose Garrard
Self-Portrait
46 × 32 × 11½in,
115 × 80 × 29cm
Resin, fibreglass, pigment

Originally trained as a sculptor in Birmingham, London and Paris, but now finds the term 'sculptor' is no longer fully appropriate to her activities, which have included television, theatre and magazines. Her first one-woman exhibition was held in Worcester in 1967, and since then he has had one-woman shows in London, Cambridge, Liverpool, Bristol, Nottingham, Rochdale, Newcastle-upon-Tyne and West Berlin. Her 1987 exhibition, mounted by the Neuer Berliner Kunstverein, toured extensively.

GLENN SUJO

ANTHONY LYSYCIA

Glenn Sujo
Self-Portrait Drawing 1987
22 × 30in, 55·9 × 76·2cm
Conte crayon
and graphite on paper

Born in Buenos Aires, Argentina, 1952. Prior to art training, taught in Venezuela. Settled in London 1972. Studied at the Slade School of Fine Art 1975 and the Courtauld Institute 1976. Sujo's first one-man exhibition in Britain toured to Bristol, London and Liverpool. Has since held one-man exhibitions in Caracas, Oxford and London. Glenn Sujo lives in London.

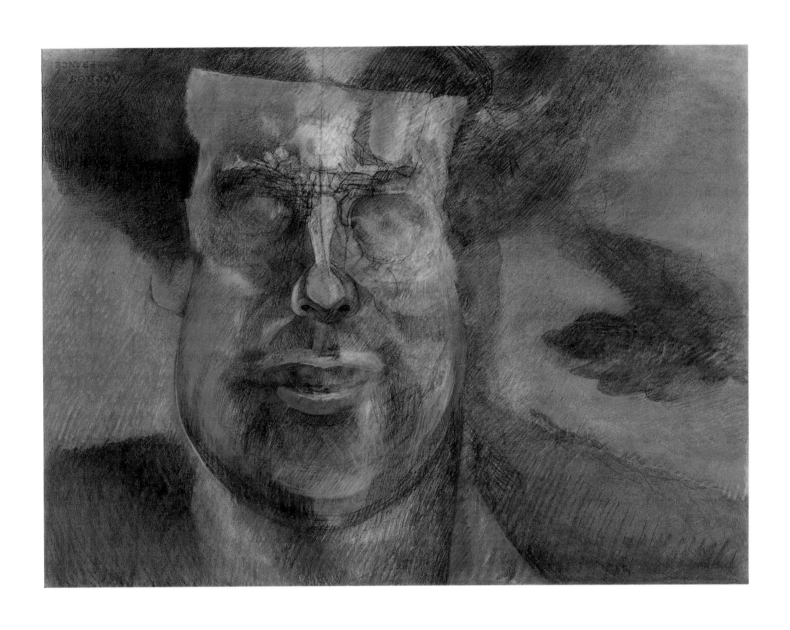

EDUARDO PAOLOZZI

Born in Leith, Scotland, 1924. Studied at the Slade School of Art, London, 1944–47. Worked in Paris, 1947–50. Taught textile design at Central School of Art, London, 1949–55. Designed a fountain for the Festival of Britain, 1951, and another for Hamburg, 1953. Taught sculpture at St Martin's School of Art, London, 1955–58. Visiting Professor at the Staatliche Hochschule fur Bildende Kunste, Hamburg, 1960–62. Visiting Professor at University of California, Berkeley, 1968. From 1968 to present, Lecturer in Ceramics at the Royal College of Art, London. Professor of Ceramics at the Fachhochscule, Cologne, 1977–81. Professor of Sculpture at the Akademie den Bildenden Kunste, Munich, 1981 to the present. Held his first one-man exhibition in London in 1947. Since then has held one-man exhibitions in London, New York, Newcastle-upon-Tyne, Otterlo, Amsterdam, Hamburg, Edinburgh, Toronto, West Berlin. Held his first retrospective at the 30th Venice Biennale, 1960.

Eduardo Paolozzi
**Self-portrait
and Strange Machine**
$37\frac{1}{8} \times 16 \times 11\frac{1}{2}$ in,
$84 \times 405 \times 285$ cm
Bronze, edition of three

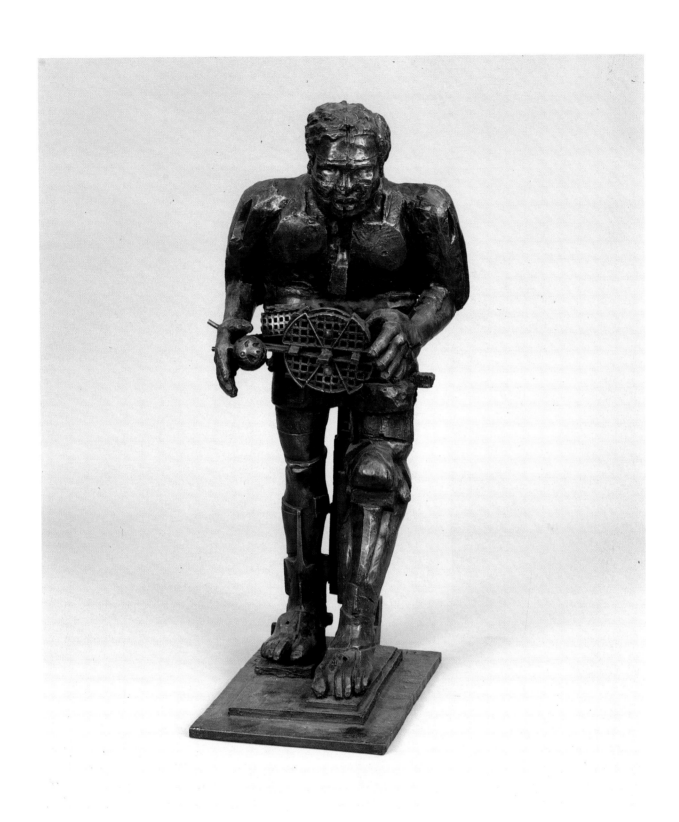

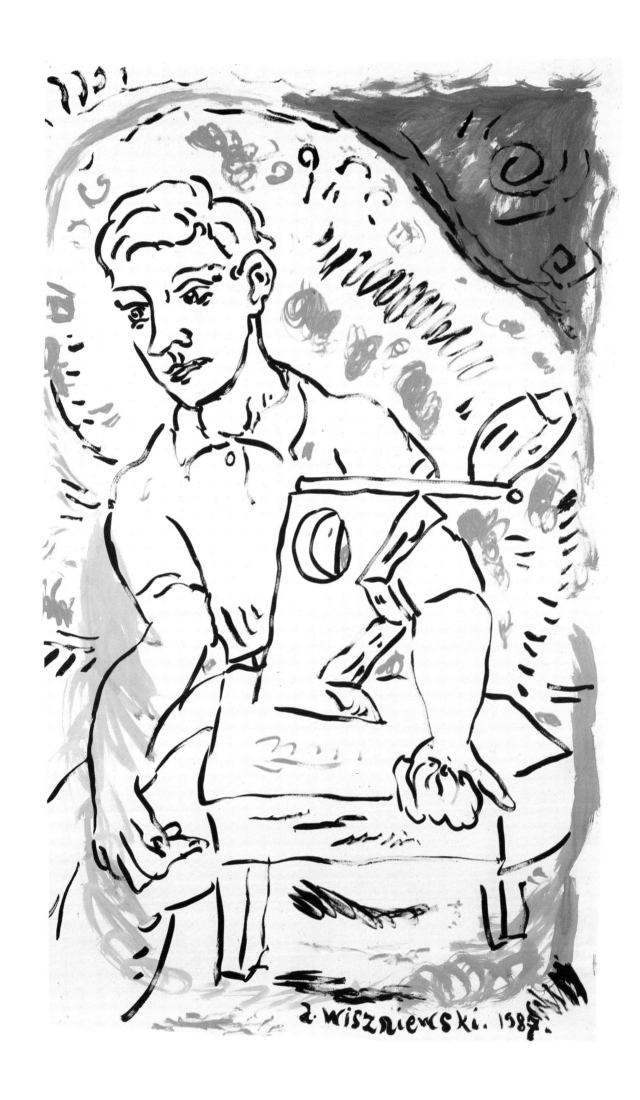

ADRIAN WISZNIEWSKI

Born in Glasgow, 1958. Studied at the Mackintosh School of Architecture, 1975–79; and at the Glasgow School of Art, 1979–83. Held his first one-man exhibition at the Compass Gallery, Glasgow in 1984, and since then has had one-man shows in London and Liverpool.

Adrian Wiszniewski
Self-Portrait 1987
60 × 40in, 150 × 100cm
Acrylic on paper

JUSTIN THOMAS

Nigel Greenwood Gallery, London

LYS HANSEN

Born in Falkirk, Scotland, 1936. Studied at Edin-
burgh College of Art, 1955–60; also at Edinburgh
College of Speech and Drama, 1955–58; and at the
University of Edinburgh, Department of Fine Art
Studies, 1969. Now part-time lecturer at Falkirk Col-
lege of Art and lecturer for the Scottish Arts Council,
Stirling University. She has held one-woman exhibi-
tions in London, Glasgow, Stirling, Belfast, Dublin,
Edinburgh and Chester. She lives in Blairlogie,
Stirling, Scotland.

Lys Hansen
Features, Fingers, Foot
36½ × 28in, 92 × 71·1cm
Oil on canvas

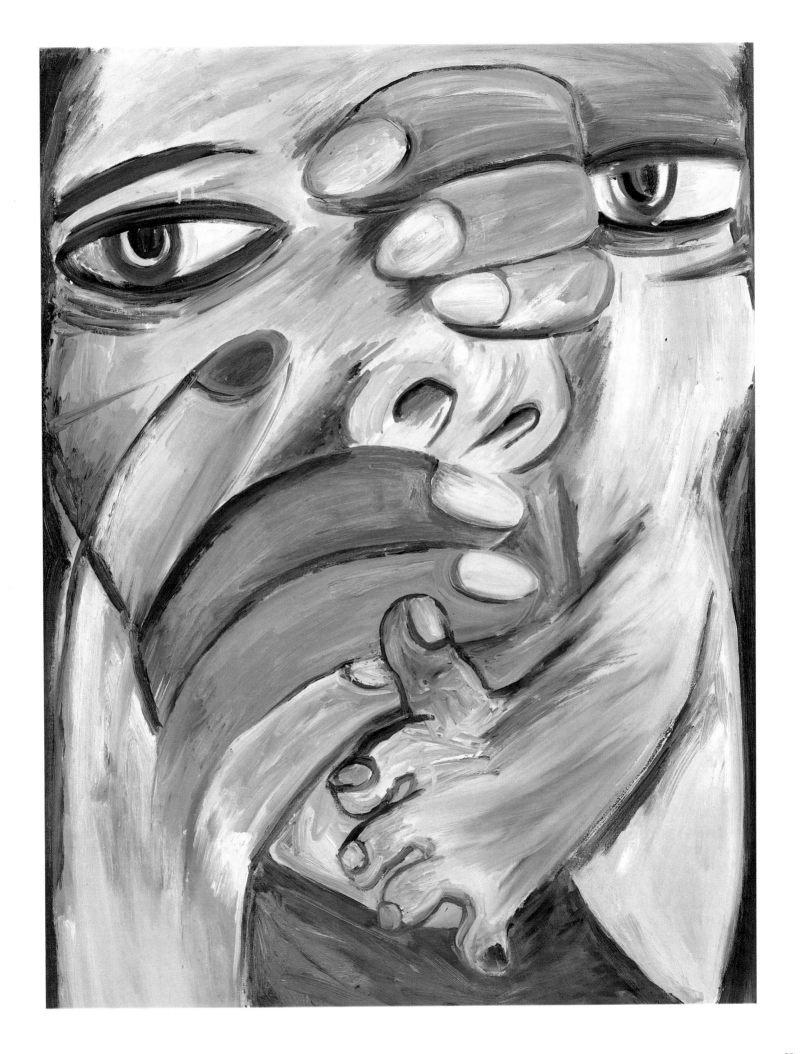

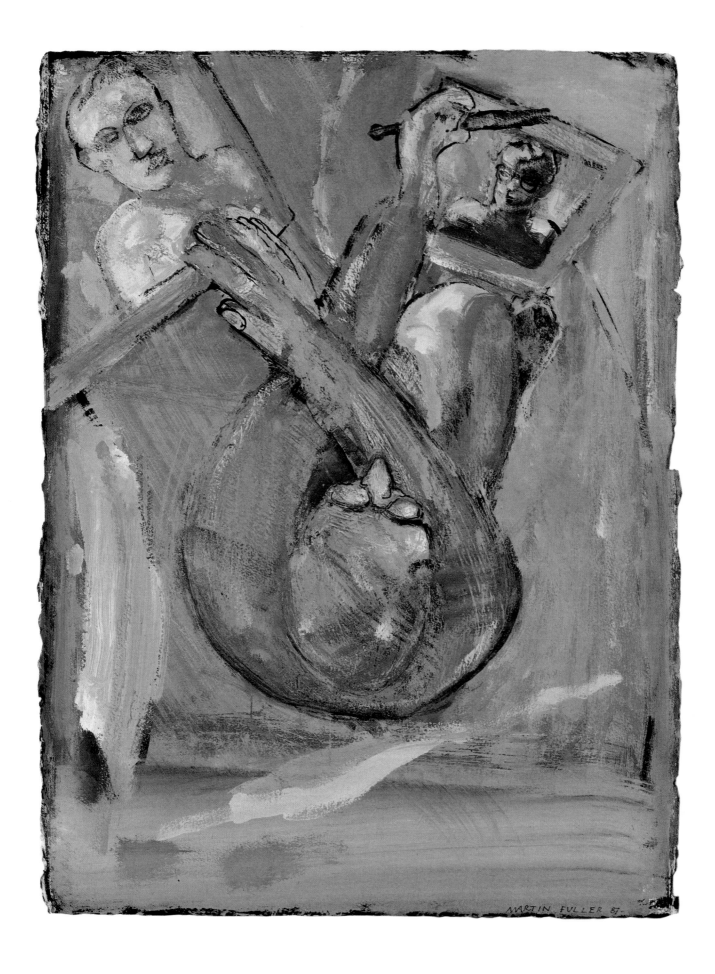

MARTIN FULLER

Born in Leamington Spa, 1943. Studied at the Mid-Warwickshire College of Art, 1960–62; and at Hornsey College of Art, 1962–64. Has worked in Italy and the United States, but now lives and works in England. His first one-man exhibition was held in Bristol in 1968, and he has since had one-man shows in Birmingham, Oxford, Bath, London, Dusseldorf, Belfast and Dublin.

Martin Fuller
Me
$30\frac{1}{4} \times 23\frac{1}{4}$in, 76·8 × 59cm
Watercolour
and gouache on paper

Austin Desmond Fine Art, Sunninghill

LAURA FORD

Born in Cardiff. Spent part of her early childhood travelling with her family, who worked the fun-fairs. Later lived in Porthcawl where her father had a fruit-machine business. Studied at Bath School of Art, Corsham, and later at the Cooper Union, New York. Currently teaches part-time at the Chelsea School of Art.

Laura Ford
Self-Portrait
$20\frac{1}{2} \times 24 \times 10\frac{1}{2}$in,
$52 \times 61 \times 26\cdot7$cm

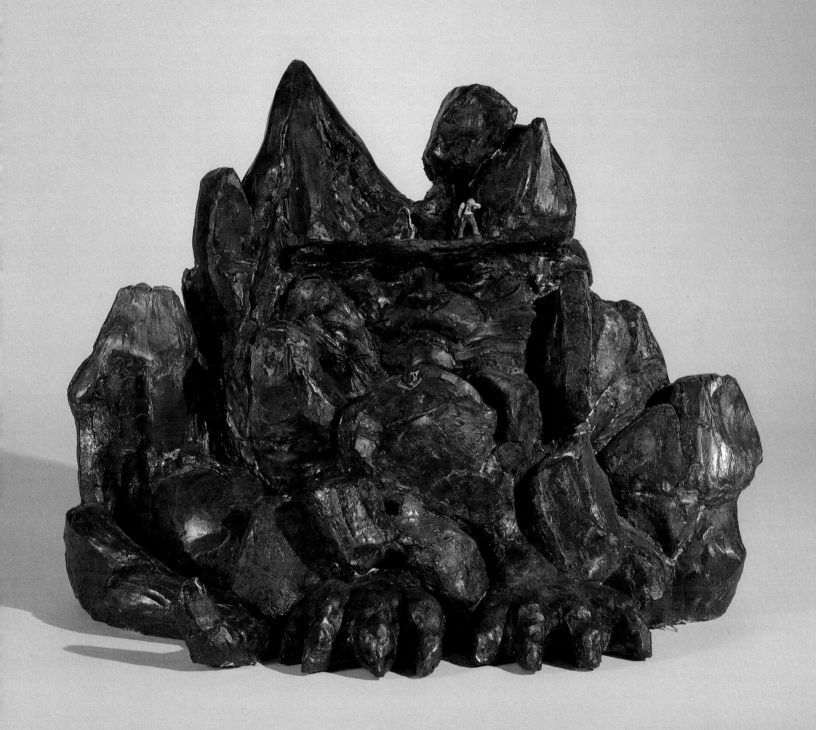

JEFFERY CAMP

Jeffery Camp
Tower Bridge
beyond London Bridge
36 × 28in, 91·5 × 71·1cm
Oil on canvas

Born in Oulton Broad, Norfolk, in 1923. Studied at
Norwich and Ipswich art schools, 1939–40; and at
Edinburgh College of Art, 1941–44. Elected A.R.A.
in 1974, and R.A. in 1984. Held his first one-man
exhibition in Edinburgh in 1950, and has since had
a series of one-man shows in London, including one
at the Serpentine Gallery in 1978.

Nigel Greenwood Gallery, London

GARY WATERS

GARY WATERS

Gary Waters
Two Studies
for a Self-Portrait
8 × 15⅜in, 20·2 × 39·1cm
Acrylic on board

Born in 1953. Studied at Hornsey College of Art, Birmingham Polytechnic and the Royal College of Art, London. Began his career as a photographer. Held his first one-man exhibition in Yugoslavia in 1982, and has since had one-man shows in Cardiff and Halifax.

JOHN KEANE

Born Hertfordshire, 1954. Studied at Camberwell School of Art, 1972–76. Artist in residence, Whitefield School, London, 1987. Has held five one-man exhibitions in London since 1980.

ISABELLE BLONDIAU

John Keane
Satirical Poodle
33 × 32¼in, 83·8 × 83·2cm
Oil on canvas

Angela Flowers Gallery, London

BARRY FLANAGAN

Born in Prestatyn, Flintshire, North Wales, 1941. Studied sculpture at St Martin's School of Art, 1964–66. Held his first one-man exhibition at the Rowan Gallery, London, in 1966. Has since held one-man exhibitions in Milan, Kassel, New York, Venice, Sydney, Amsterdam, Paris, Cologne, Chicago. Represented Britain in the 40th Venice Biennale of 1982, and was included in Documenta 7, Kassel, also in 1982.

Barry Flanagan
Self-Portrait 1981
15 × 10½in, 38·1 × 26·7cm
Charcoal and
watercolour on paper

SHIGEO ANZAI

Waddington Galleries, London

ROD JUDKINS

Born in England, 1956. Studied at Bath Academy of Art, Corsham, 1976–77; Maidstone College of Art, 1977–80; and the Royal College of Art, London, 1980–83. His first one-man exhibition was held in London in 1983, and he has since had three more one-man exhibitions in London.

Rod Judkins
Double Self-Portrait
$37\frac{1}{2} \times 28\frac{3}{4}$in, 95·2 × 73cm
Pastel

Thumb Gallery, London

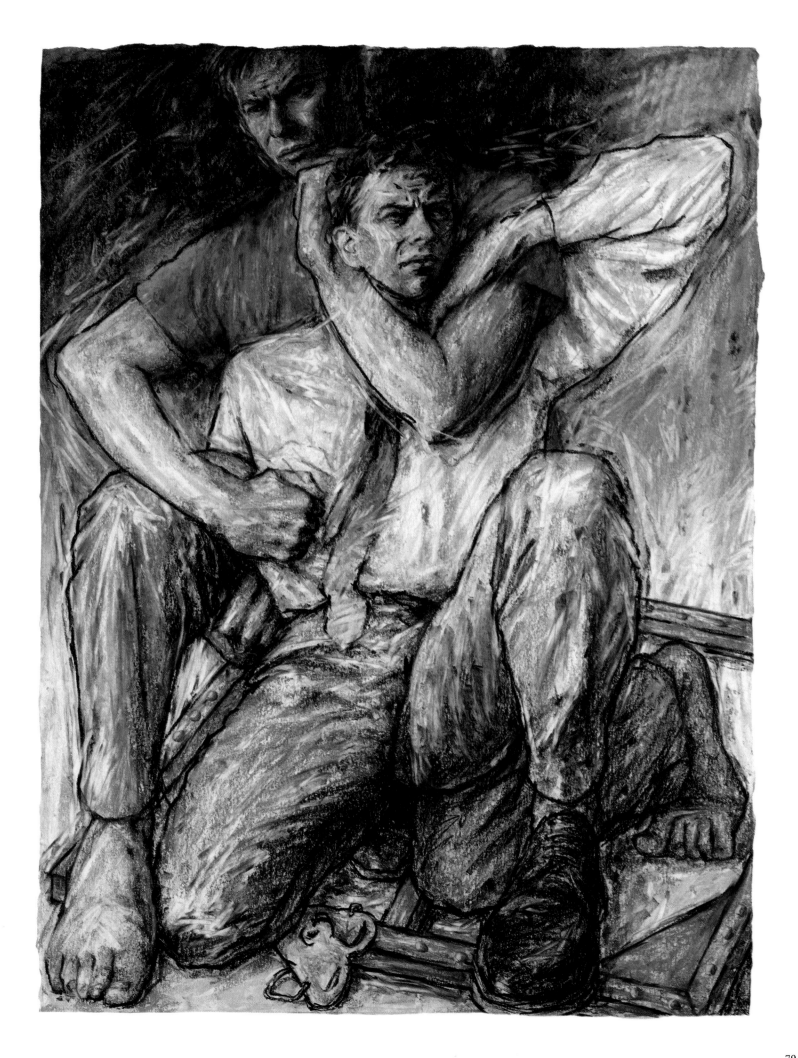

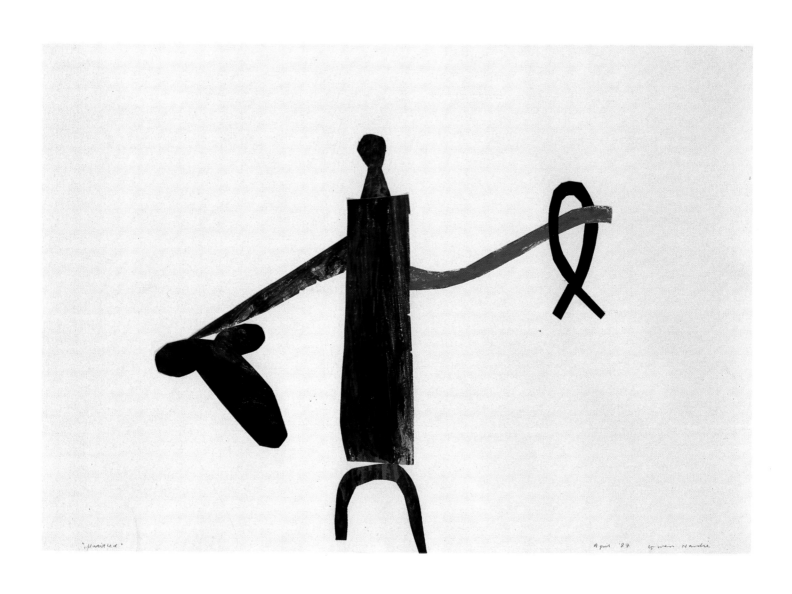

"Untitled"

April '87 Gwen Hardie

Gwen Hardie
Self-Portrait
$27\frac{3}{4} \times 39\frac{1}{2}$in, 70·5 × 100cm
Mixed media on paper

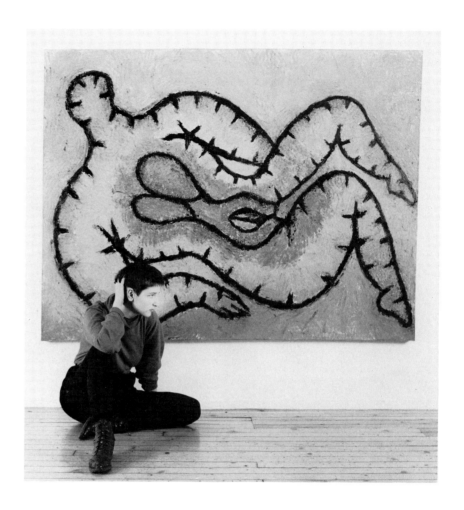

GWEN HARDIE

Born in Newport, Fife, 1962. Studied at Edinburgh College of Art, 1979–84. Her first one-woman exhibition was held in Glasgow in 1984, and she has since had one-woman shows in London, Edinburgh, Dundee and Aberdeen. She currently lives in West Berlin.

Graham Paton Gallery, London

ANTHONY LYSYCIA

Born at Chorley, Lancashire, 1959. Studied at Preston Polytechnic, 1978–81; and at the Royal College of Art, London, 1981–84. In 1984–85 was Rome scholar in Printmaking at the British School in Rome. He has participated in a number of group exhibitions in London and elsewhere.

Anthony Lysycia
Face behind a Tree
19 × 28 × 10in,
48·2 × 71 × 25cm
La Pine stone

SURINDER SINGH JUTTLA

83

PETER BLAKE

ANTHONY LYSYCIA

Peter Blake
Self-Portrait
(work in progress)
$6\frac{3}{4} \times 5$in, $16\cdot5 \times 12\cdot7$cm
Acrylic on canvas

Born in Dartford, Kent, 1932. Studied at Gravesend School of Art and the Royal College of Art 1950. Served in the RAF 1951–53. Returned to the Royal College of Art 1953–56. Travelled in Europe extensively 1956 and 1957. Lectured at various art schools in England from 1960 to 1976. Held his first one-man exhibition in London in 1962. Has since had one-man exhibitions in Bristol, Amsterdam, Hamburg, Paris, Brussels, London, and Japan. A major retrospective was held at the Tate Gallery, London in 1983 and subsequently toured to Germany. Elected R.A. 1981. Lives and works in London.

Waddington Galleries, London

GRAHAM CROWLEY

Born in Romford, 1950. Studied at St Martin's School of Art, 1968–72; and at the Royal College of Art in 1972. Artist in Residence to Oxford University 1982–83, and Visiting Fellow at St Edmund Hall. Member of the Faculty Board (School of Painting) at the British School in Rome, 1981 to date. Held his first one-man exhibition in London in 1982, and has since held four exhibitions in London and one in New York, in addition to being the subject of a touring show based on the Museum of Modern Art, Oxford, and of another based on the Orchard Gallery, Londonderry, Northern Ireland. Currently lives and works in Cardiff.

Graham Crowley
Ghosts
27 × 20in, 68·6 × 50·8cm
Oil on canvas

Edward Totah Gallery, London

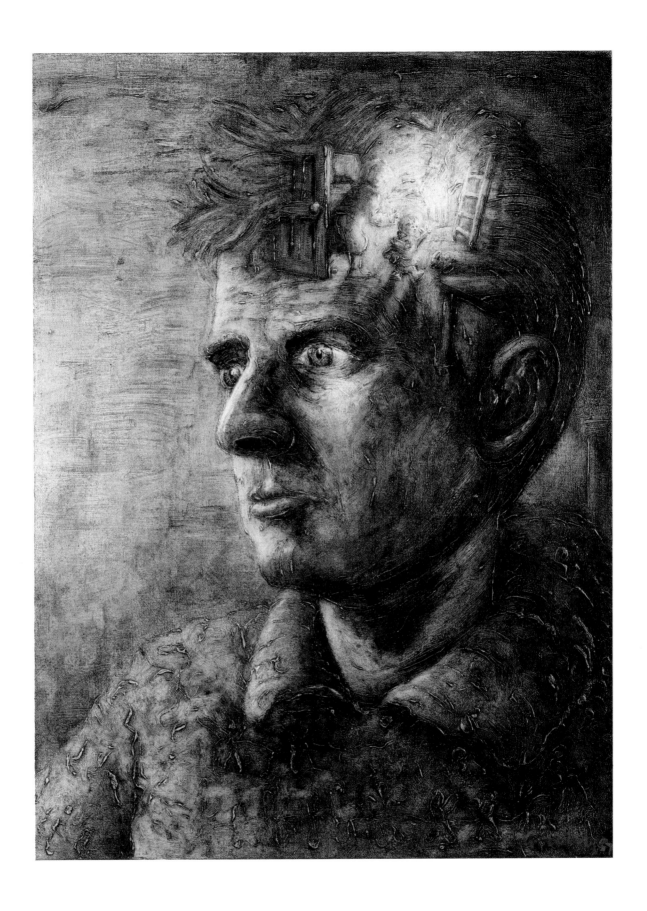

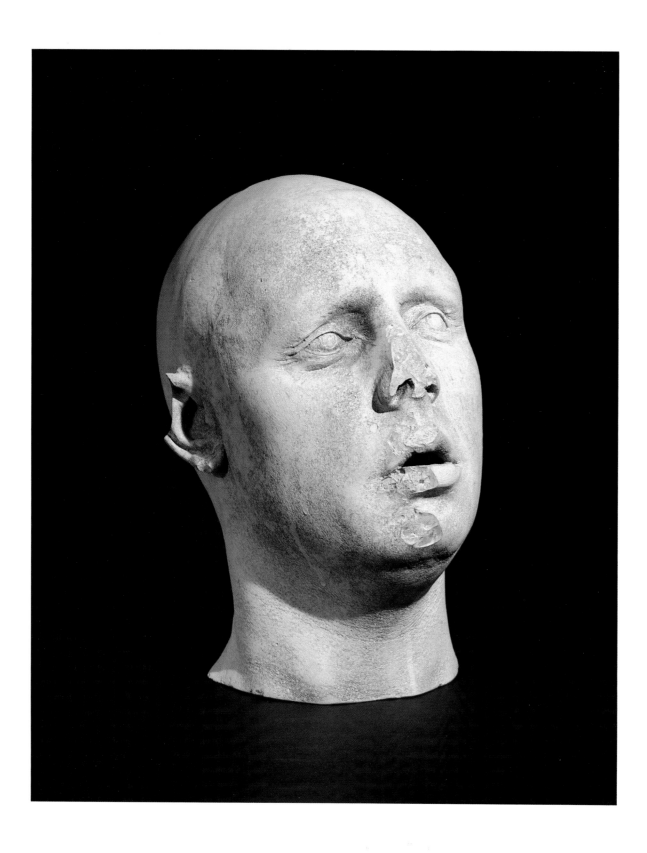

MALCOLM POYNTER

Malcolm Poynter
Self-Portrait
$7\frac{1}{2} \times 10 \times 11$in,
$19 \times 25{\cdot}4 \times 28$cm
Fibreglass

Studied at Goldsmiths College, 1967–70, and at the Royal College of Art, London, 1970–73. Held his first one-man exhibition in London in 1976. Since then has held one-man exhibitions in Sheffield, Colchester, Newcastle, Brussels, Cardiff, Bristol, Nottingham, Birmingham, Berlin and Sydney. He has collaborated with Peter Gabriel and other pop musicians on videos and designs for L.P. albums, has done theatre work and performances, and has also designed jewellery.

Nicholas Treadwell Gallery, Bradford

89

PETER HOWSON

Born in London, 1958, but moved to Scotland in 1962. Studied at Glasgow School of Art, 1975–79, then spent two years in the Scottish infantry and doing a variety of odd jobs. Artist in residence, St Andrew's University, 1985. Part-time tutor, Glasgow College of Art. His first one-man exhibition – of mural drawings – was held at the Feltham Community Association in London in 1982. Since then he has had one-man exhibitions in Glasgow, St Andrew's and London.

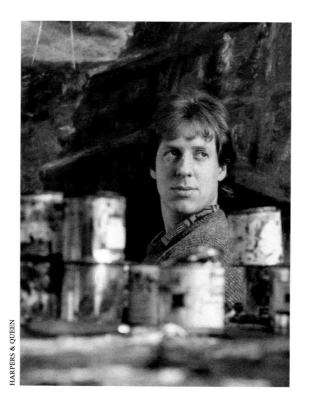

HARPERS & QUEEN

Peter Howson
Self-Portrait
$35\frac{3}{4} \times 29\frac{5}{8}$in, $90{\cdot}8 \times 75{\cdot}2$cm
Oil on canvas

Graham Paton Gallery, London

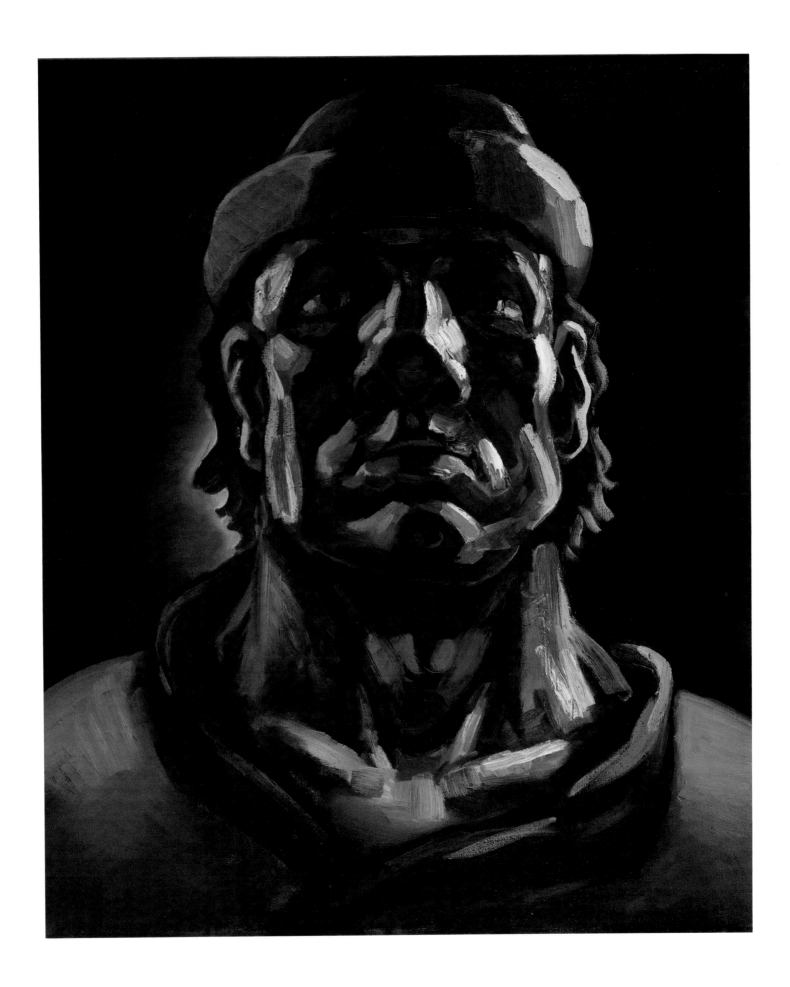

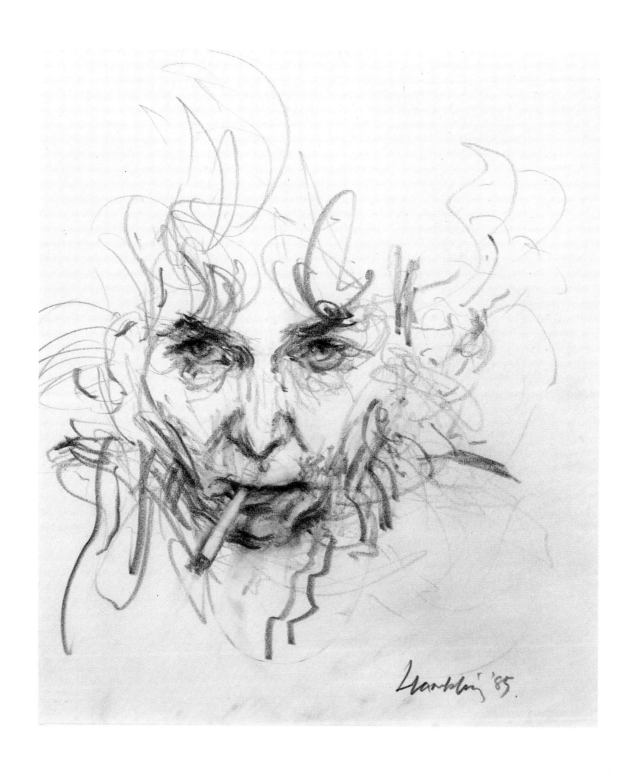

MAGGI HAMBLING

Born in Suffolk, 1945. Studied at Ipswich School of Art, 1962–64; Camberwell School of Art, 1964–67; and the Slade School of Art, 1967–69. She was the first Artist in Residence at the National Gallery, London, in 1980–81. Her first one-woman exhibition was held in Suffolk in 1967. Since then she has had four one-woman shows in London, and has been the subject of a National Portrait Gallery touring exhibition. In October 1987 she will have a major exhibition at the Serpentine Gallery. She lives and works in London.

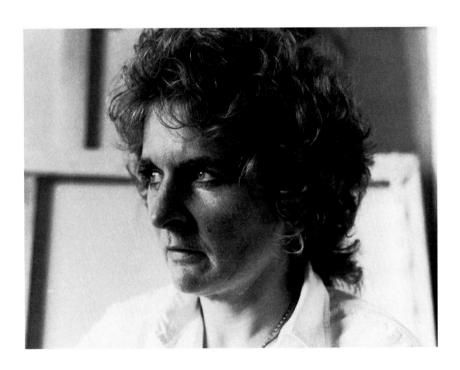

Maggi Hambling
Self-Portrait Working 1985
8 × 7in, 20·2 × 17·8cm
Graphite on paper

ANTHONY GRIFFITHS

Born in Oxford, 1960. Studied at Bournville School of Art and Craft, 1978–80, and at Bath Academy of Art, Corsham, 1980–83. He held his first one-man exhibition in Bath in 1986.

ANTHONY LYSYCIA

Anthony Griffiths
Self-Portrait
$23 \times 20 \times 12\frac{1}{2}$in,
$58\cdot4 \times 50\cdot8 \times 31\cdot8$cm
Limewood

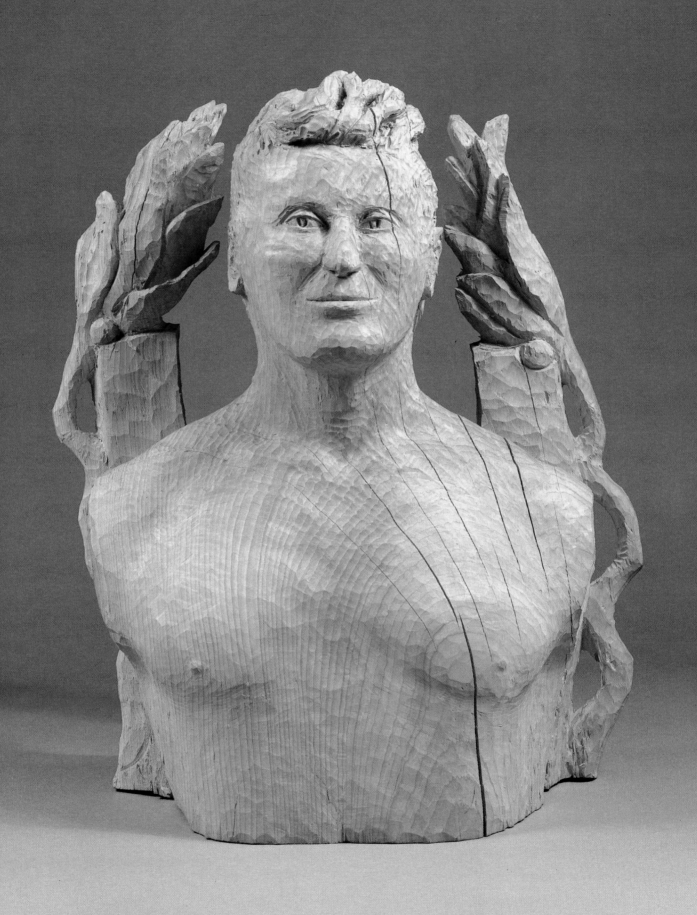

CLARE ROWE

Keir Smith
Self-Portrait
30 × 22in, 76·2 × 56cm
Rust on paper

Born in Kent, 1950. Studied at the University of Newcastle-upon-Tyne, 1969–73, and did postgraduate studies at Chelsea College of Art, 1973–75. Was Junior Fellow at Cardiff College of Art, 1975–76, and is currently associate lecturer at the Birmingham Polytechnic School of Fine Art. Held his first one-man exhibition in 1977 at the Hays Gallery, Sheffield, and has since held one-man shows in London, Newcastle-upon-Tyne, Sunderland, Edinburgh, Rochdale, Portsmouth, Cardiff and Liverpool. His most recent one-man exhibition was at Artsite, Bath, in 1986.

SIMON EDMONDSON

Born in London, 1955. Studied at the City and Guilds
School of Art, 1973–74; the Kingston Polytechnic,
1974–77; and at Syracuse University, NY, in 1978–
80. Held his first one-man exhibition in Syracuse in
1979, and has since had one-man shows in London,
Berlin, Zurich and New York.

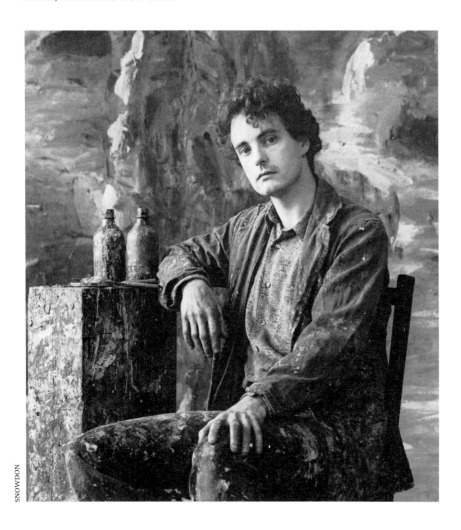

SNOWDON

Simon Edmondson
Self-Portrait –
Virtues of Touch
$32\frac{1}{2} \times 28$in, 83·2 × 71cm
Oil on canvas

Nicola Jacobs Gallery, London

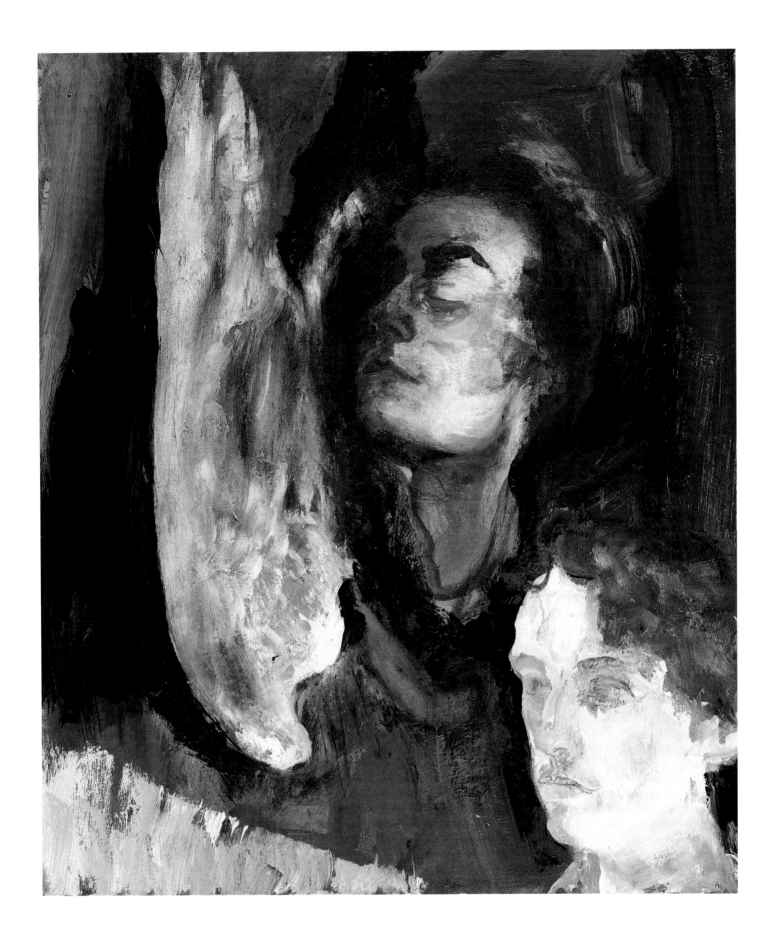

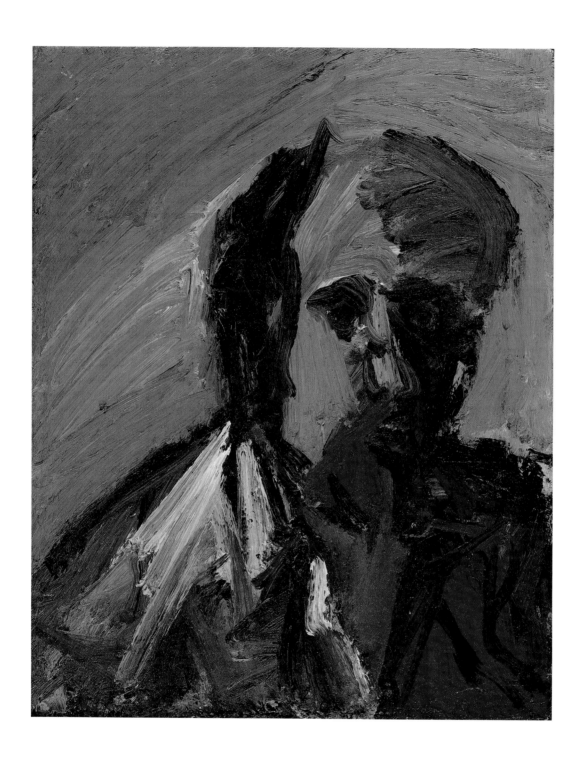

PETER PRENDERGAST

Born in Abertridwr, Glamorgan, 1946. Studied at
Cardiff College of Art, 1962–64; at the Slade School,
1964–67; and at the Department of Fine Art, Reading
University, 1968–70. Moved to live and paint in
Bethesda, Wales, 1970. Since 1980 has taught part-
time on the Foundation Course, Gwynned Technical
College, Bangor. He has had one-man exhibitions in
Liverpool, Bangor, Cleveland, Cardiff, Llandudno,
Durham, Swansea and London. His most recent one-
man show was at Artsite, Bath, in 1987.

Peter Prendergast
Peter Prendergast Nov '86
$16\frac{1}{4} \times 13$in, $41 \cdot 2 \times 33$cm
Oil on canvas

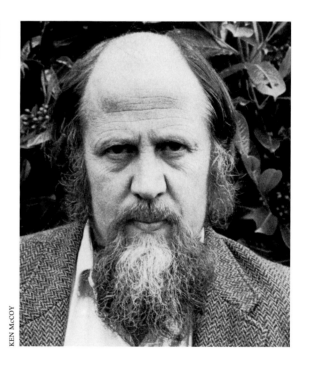

KEN McCOY

MARY MABBUTT

Born in Luton, 1951. Studied at Luton College of Art, 1970–71; at Loughborough College of Art, 1971–74; and at the Royal Academy Schools in London, 1975–78, was Junior Fellow in Painting at South Glamorgan Institute of Higher Education in 1978–79. From 1979–87 has been part-time lecturer in painting at various art schools in England. She has had two one-woman exhibitions in London, the first of which was in 1980.

Mary Mabbutt
**Self-Portrait
in Red Jacket, May 1987**
36 × 28in, 91·5 × 70cm
Oil on canvas

Graham Paton Gallery, London

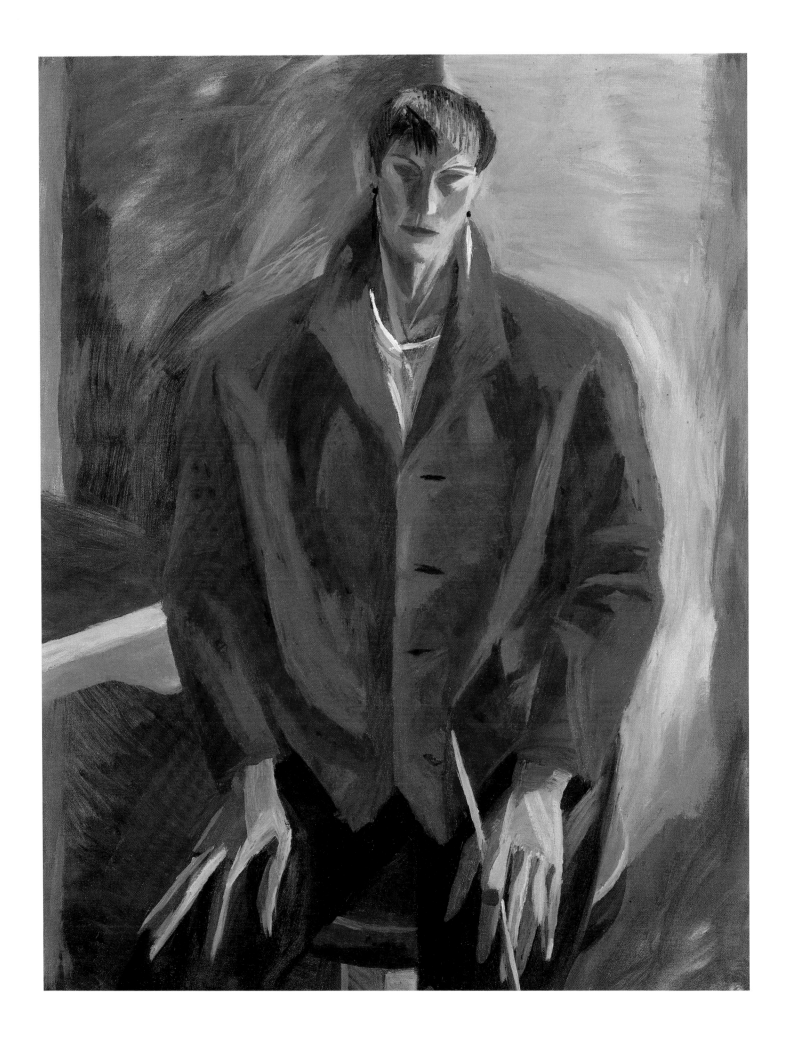

Michael Murfin
Self-Portrait 1987
$17\frac{3}{4} \times 18\frac{1}{4}$in, 45·1 × 46·3cm
Acrylic on board

Born in St Neots, Cambridgeshire, 1954. Studied at Leicester Polytechnic, 1972–73; Trent Polytechnic, Nottingham, 1975–76; Birmingham Polytechnic, 1976–77. Held his first one-man exhibition in 1978 at Huntingdon Public Library, and his first one-man show in London in 1983. Since then has had two more one-man exhibitions in London and others at Sudbury and King's Lynn. Lives and works in St Neots.

Piccadilly Gallery, London

VINCENT WOROPAY

Born in 1957. Grew up in London and Los Angeles. Prior to formal training he worked for three years as a musician. Studied at Brighton Polytechnic 1974–77 and the Slade School of Fine Art 1977–79. Awarded a Rome scholarship 1979–81. Woropay's first one-man exhibition was held at Eton College in 1983. Has since had one-man exhibitions in Cambridge, Cardiff and London. He currently lives in London.

Fabian Carlsson Gallery, London

Vincent Woropay
En Paquet
$22\frac{1}{2} \times 7\frac{3}{4} \times 7\frac{3}{4}$in,
$56\cdot5 \times 20 \times 20$cm
Carved wood, gesso, silver gilt

STEPHEN FARTHING

Born in London, 1950. Studied at St Martin's School of Art, 1968–73, and at the Royal College of Art, 1973–76. Lecturer in Painting at Canterbury College of Art, 1977–79. Since 1980 has taught at the Royal College of Art; and since 1985 has been Head of the Department of Painting, West Surrey College, Farnham. Held his first one-man exhibition in Liverpool in 1981 (this later toured), and has since had one-man exhibitions in Bristol and London, plus a second touring exhibition based on the Museum of Modern Art, Oxford.

JOHN KNIGHT

Stephen Farthing
Self-Portrait
$31\frac{1}{4} \times 23\frac{1}{2}$in, $79\cdot3 \times 59\cdot6$cm
Mixed media on canvas

Edward Totah Gallery, London

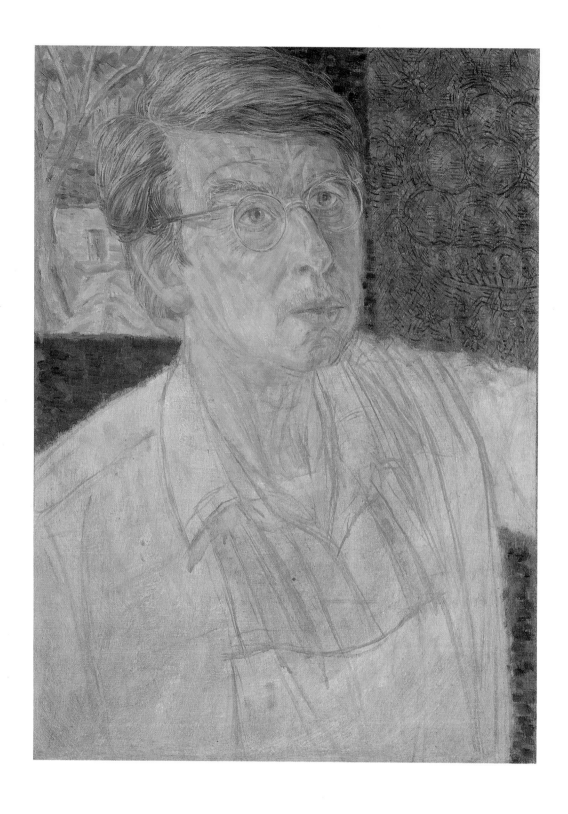

110

LEONARD McCOMB

Born in Glasgow, 1930. Attended Junior Arts School, Manchester, 1945–47. Worked in a commercial art studio, Salford, 1947–48 and 1950–51. Worked as a freelance designer, 1951–54. Attended Regional College of Art, Manchester, 1954–56; and the Slade School of Fine Art, London, 1959–60. Taught drawing, painting and sculpture at the West of England College of Art, Bristol, 1960–64. Head of Foundation Studies, Oxford Polytechnic, 1964–77. Taught part-time at Slade School of Fine Art; City of Canterbury

Leonard McComb
Self-Portrait
(work in progress)
$21\frac{5}{8} \times 16\frac{1}{8}$in, 55×41cm
Oil on canvas
stretched on board

BARBARA McCOMB GITTEL

College of Art; Winchester School of Art. At present part-time teacher at the Sir John Cass School, Goldsmiths' College and the Royal Academy Schools, London. Has destroyed most of his work made before 1975. An exhibition organised by the Museum of Modern Art, Oxford, toured to London, Oxford, Manchester, the University of Sussex and Edinburgh in 1983–84.

Edward Totah Gallery, London

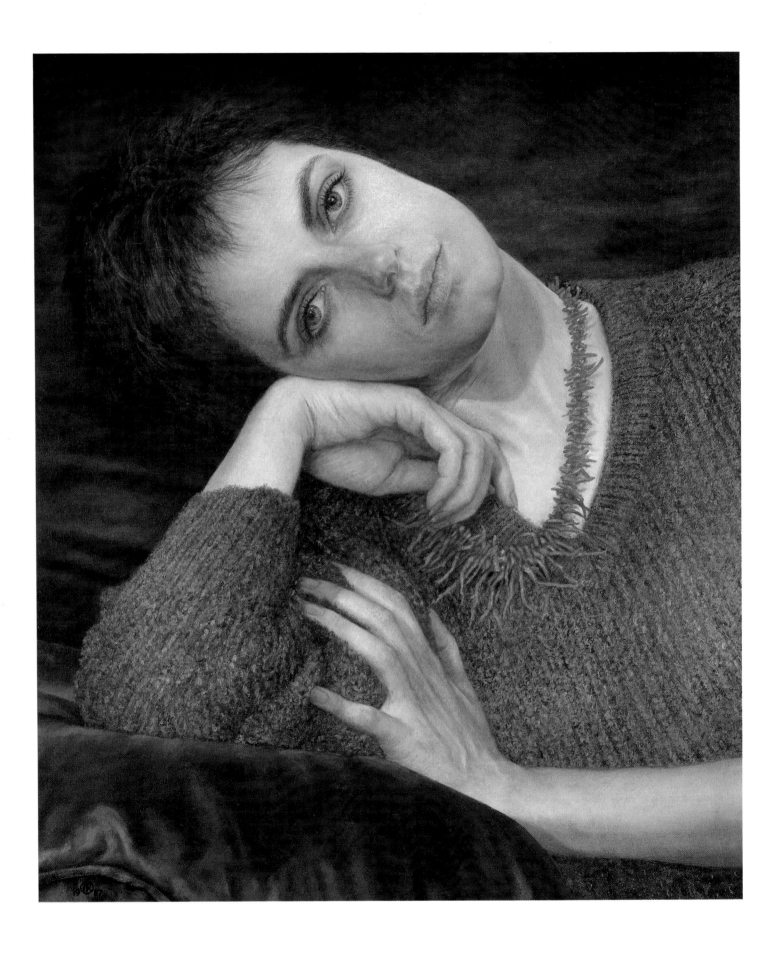

Sara Rossberg
Self-Portrait
32 × 28in, 81·2 × 71·1cm
Acrylic on canvas

SARA ROSSBERG

Born in Reckinghausen, Germany, 1952. Studied at the Academy of Fine Art, Frankfurt-am-Main, 1971–76. Awarded a German government scholarship, 1973, and continued her studies as a post-graduate student at Camberwell School of Art. Held her first one-woman exhibition in Frankfurt in 1973. Has since held one-woman exhibitions in Basle and Berne.

Nicholas Treadwell Gallery, Bradford

ANSEL KRUT

Ansel Krut
Self-Portrait 1986
9 × 11¼in, 23 × 28·5cm
Gouache

Born in Cape Town, South Africa 1959. Studied at the University of Witwatersrand, Johannesburg 1979–82, following which he lived at Cité Internationale des Arts, Paris 1982–83. Attended the Royal College of Art, London 1983–86. Awarded the Prix de Rome 1986–87. Held his first one-man exhibition in Johannesburg in 1984, and since then he has exhibited in London and Rome.

Fischer Fine Art, London

PETE DAVIS

ROGER MOSS

Born in Lancaster, Lancashire, 1949. Studied sculpture at the Central School of Art and Design, London, 1967–71. Later worked as studio assistant to Barry Flanagan, William Turnbull and Brian Wall, in addition to undertaking projects for theatre and television for 'Sculpture Constructional Designs'. Became a part-time lecturer in sculpture at Dyfed College of Art, 1974; moved to West Wales in 1976. Since 1982 has been Head of Sculpture at Carmarthenshire College of Technology and Art, Faculty of Art, Carmarthen. His work has been included in numerous mixed exhibitions held in Wales, from 1978 onwards.

RB KITAJ

Born in Cleveland, Ohio, 1932. First arrived in Europe 1951, studied at the Akademie der Bilden Kunste, Vienna. Returned to New York, 1953. Came to Britain in 1957. Studied at the Ruskin School of Drawing and Fine Art, Oxford. Entered the Royal College of Art, London, in 1960, where he formed a lifelong friendship with David Hockney. Held his first one-man exhibition in London in 1963 and his first solo exhibition in New York, 1965–66. Left London in 1967 to teach as visiting professor at the University of California, Berkeley. Returned to London, 1968. Taught as visiting professor at the University of California, Los Angeles, 1970. Returned to London once more in 1971. One-man exhibitions have been held in Ljubljana, Birmingham, Zurich and Washington D.C.

RB Kitaj
Self-Portrait
$22\frac{1}{4} \times 14\frac{3}{4}$in, 56·5 × 37·5cm
Charcoal and paper

Marlborough Gallery, London

TIMOTHY HYMAN

Born 1946. Studied at the Slade School of Fine Art, 1963–67. Was visiting professor at the University of Baroda, India, 1980–81; artist in residence at Lincoln Cathedral, 1983–84; visiting artist at Westfield College, London, 1984–85. His first one-man exhibition was held in London in 1981. Since then he has had one-man exhibitions in London and Lincoln, and has been the subject of a touring exhibition mounted by the Ulster Art Gallery. He is also well-known as an exhibition curator, especially for the controversial *Narrative Paintings*, 1979.

Timothy Hyman
Self-Portrait 1987
25⅜in, 64·5cm diameter
Acrylic on board

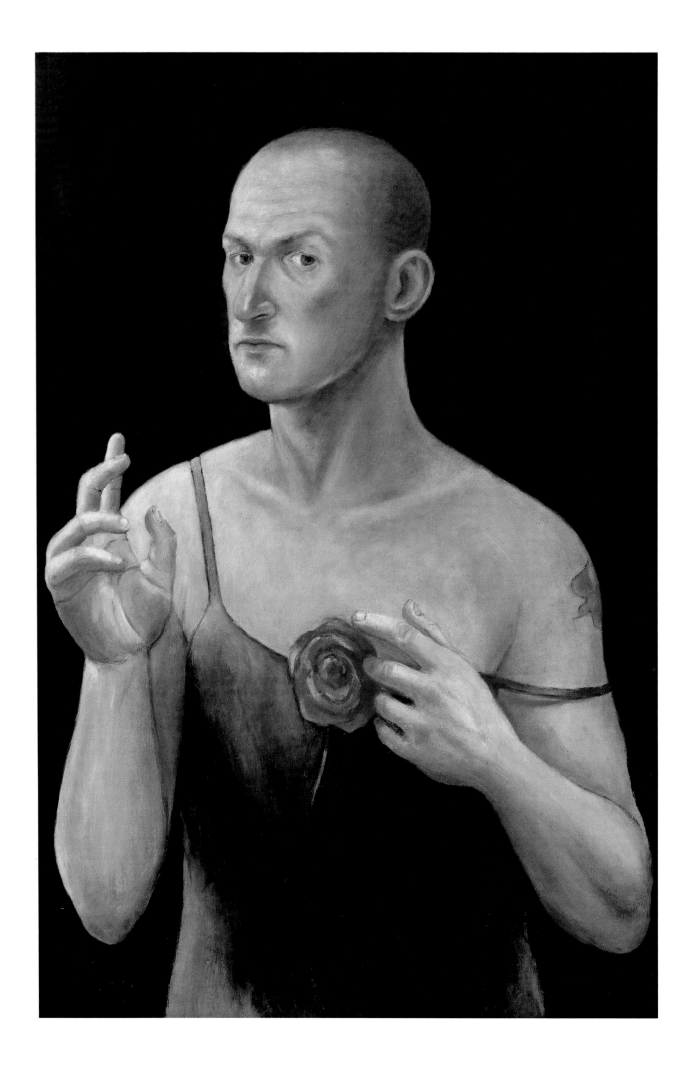

JOHN KIRBY

Born in Liverpool, 1949. Worked as an office junior/ shipping clerk in Liverpool, 1965–67, and subsequently as a book-salesman, social worker, deputy warden of a boys' hostel, probation officer, stage doorman and market stallholder. Attended St Martin's School of Art, 1982–85, and is now a first year student at the Royal College of Art.

ISABELLE BLONDIAU

John Kirby
Self-Portrait
$35\frac{3}{4} \times 23\frac{5}{8}$in, $90 \cdot 8 \times 60$cm
Oil on board

BERNARD DUNSTAN

Born in Teddington, 1920. Educated at St Paul's School, and the Byam Shaw and Slade Schools of Art. Taught painting for many years at various art schools. Member of the Royal Academy, Royal West of England Academy, New English Art Club. Has held regular one-man shows at Agnew's. He is the author of several books on painting, including *Paintings in Progress* and *Painting Methods of the Impressionists*.

Bernard Dunstan
**Self-Portrait
with Diana Convalescent**
$13\frac{1}{2} \times 15\frac{1}{4}$in, 34·2 × 38·7cm
Oil on board

Thos. Agnew & Sons Ltd., London

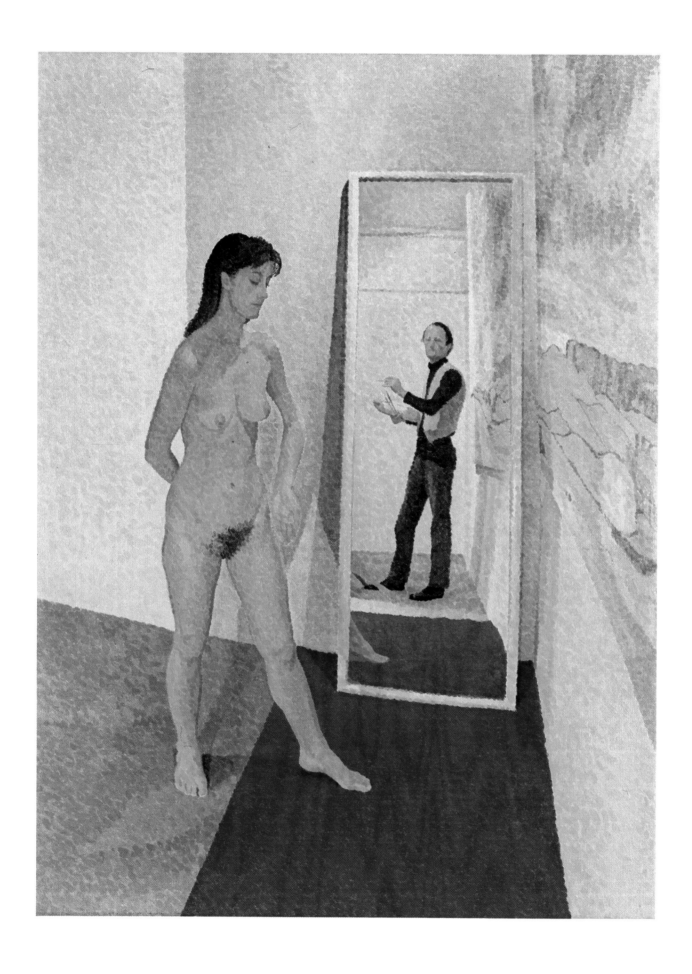

Born 1938. Studied at Swansea College of Art and at the Royal College of Art, London. After a period of teaching, joined the Greater London Council's Department of Architecture as an architectural journalist, and was responsible for organising many architectural exhibitions, and for developing a pioneering programme of architectural education in secondary schools. Has painted full-time since 1977.

William Wilkins
Artist and Model
30 × 22½in, 76·2 × 57·2cm
Oil on canvas

His first one-man show was at the University College of Wales, Aberystwyth, in 1970. Since then he has had one-man exhibitions in Cardiff, London, Warsaw, Swansea, New York, Palm Beach and San Francisco.

KEVIN SINNOTT

Born in Wales 1947. Studied at Gloucester College of Art and Design 1968–71 and the Royal College of Art 1971–74. Part-time tutor at St Martin's School of Art. Recent one-man exhibitions include Birmingham, London, Cardiff and New York.

Kevin Sinnott
Self-Portrait
$11\frac{3}{8} \times 8\frac{3}{8}$in, 29 × 21·3cm
Oil on board

Bernard Jacobson Gallery, London

KEN TOWNER

ELISABETH FRINK

Born at Thurlow, Sussex, in 1930. Studied at Guildford School of Art, 1947–49; then at Chelsea School of Art, 1949–53. Taught at Chelsea School of Art, 1953–61, and at St Martin's School of Art, 1954–62. Visiting Instructor, Royal College of Art, 1965–67. Moved to France in 1967. Elected A.R.A. 1971. Returned to England, 1973. Moved to her present home in Dorset, 1976. Awarded DBE, 1982. Held her first one-woman exhibition in London in 1955, and has since had one-woman shows in London, New York, Toronto and Los Angeles.

Elisabeth Frink
Self-Portrait
19⅝in, 50cm high
Plaster and paint
(for casting in bronze)

JOCK McFADYEN

ISABELLE BLONDIAU

Jock McFadyen
Self-Portrait
36 × 24in, 91·5 × 61cm
Oil on canvas

Born in Paisley, Scotland, 1950. Studied at Chelsea School of Art, 1973–74. Is currently part-time lecturer at the Slade School of Art, London. He held his first one-man exhibition in London in 1978, and has since had seven one-man exhibitions in London, plus one-man shows in Jarrow, Leeds, and Glasgow. An exhibition travelling to Sunderland, Birmingham, Stoke-on-Trent, Bolton, Hull, Belfast and London began its tour in 1986. Jock McFayden lives in London.

EILEEN COOPER

Eileen Cooper
Fisherwoman
$36 \times 28\frac{1}{4}$in, $91 \cdot 5 \times 71 \cdot 7$cm
Oil on canvas

Born in Glossop, Derbyshire, 1953. Studied at
Goldsmiths College, 1971–74, and at the Royal Col-
lege of Art, London, 1974–77. Held her first one-
woman exhibition in London in 1979, and has since
had one-woman shows in London, Aberdeen,
Manchester and Bath. Is currently a part-time lec-
turer at St Martin's and Camberwell Schools of Art,
and an external examiner at the Slade School of Art.

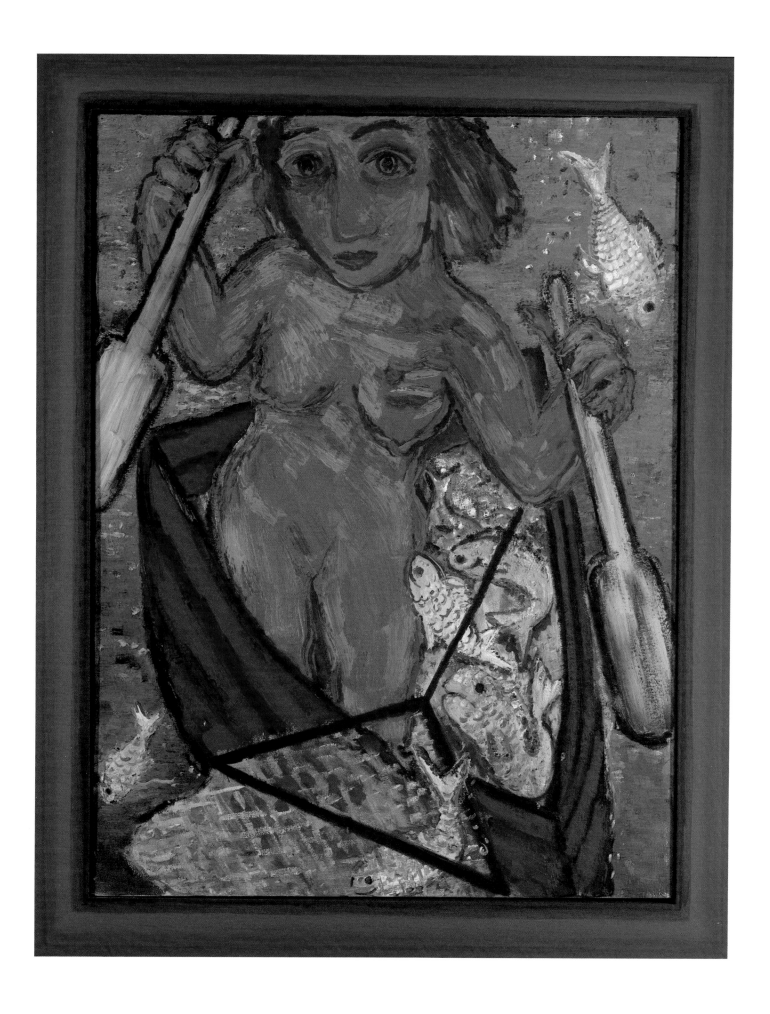

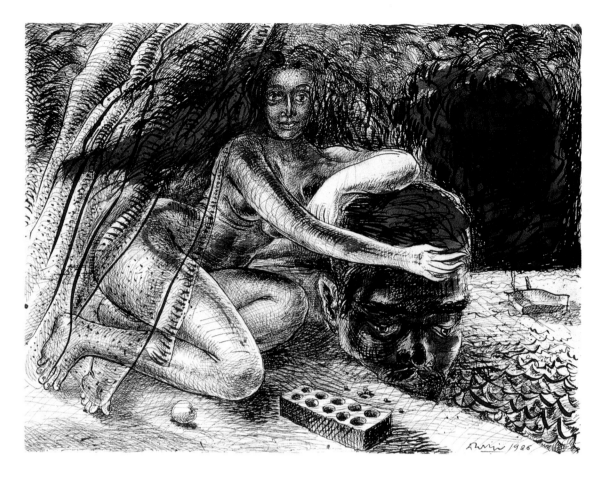

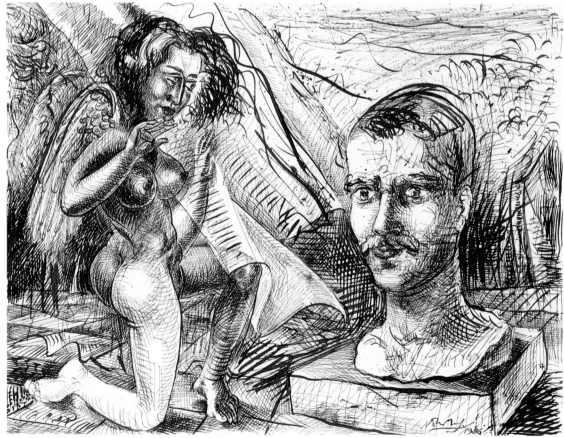

DHRUVA MISTRY

Born in Kanjari, India, 1957. Studied sculpture and
fine arts at the University of Baroda, 1974–81, then
at the Royal College of Art, London, 1981–83. Artist
in Residence at Kettle's Yard Gallery, Cambridge,
and Fellow Commoner at Churchill College. He held
his first one-man exhibition in New Delhi in 1981,
and this travelled to the Jehangir Art Gallery, Bom-
bay, in 1982. Since then he has had one-man shows
in Ahmedabad, and a touring exhibition based
on Kettle's Yard, which was also seen in Bristol,
Llandudno and Liverpool.

Dhruva Mistry
Self-Portrait
9 × 26½in, 22·8 × 66·7cm
Ink on paper

MEG ROBBINS

Nigel Greenwood Gallery, London

NEIL JEFFRIES

Born in Bristol 1959. Studied at St Martin's School of Art 1978–82 and at the Slade School of Fine Art 1982–84. In 1984 he was awarded a Boise Travelling Scholarship. Held his first one-man exhibition in Bristol in 1985 and has since been the subject of a one-man show in London.

Neil Jeffries
Self-Portrait
$22\frac{1}{2} \times 35 \times 14$in,
$57 \cdot 2 \times 88 \cdot 9 \times 35 \cdot 9$cm
Oil on riveted sheet-metal

JOHN BELLANY

Born in Port Seton, Scotland, 1942. His father and
both his grandfathers were fishermen. Studied at
Edinburgh College of Art in 1960–65; and at the
Royal College of Art, London, in 1965–68. Lecturer
in Painting at Winchester College of Art, 1969–73;
Head of the Faculty of Painting, Cardiff College of
Art, 1973–78; Lecturer in Painting, Goldsmiths Col-
lege 1978. Held his first one-man exhibition in Hol-
land in 1965, and has since had one-man shows in
London, Dublin, Edinburgh, Aberdeen, Glasgow,
New York, Melbourne, Perth, Sydney and
Amsterdam. A major retrospective was held at the
Scottish National Gallery of Modern Art and the
Serpentine Gallery, London, 1986. Elected A.R.A.,
1987.

ANTONIA REEVE PHOTOGRAPHY

John Bellany
Self-Portrait
30 × 23in, 75·5 × 57·5cm
Watercolour on paper

Fischer Fine Art, London

GIOVANNI BELLINI. MARCH 87.

ANTHONY CARO

Born in New Maldon, Surrey, 1924. Educated at Christ's College, Cambridge, 1942–44. Served in the Fleet Air Arm, 1944–46. Studied at the Regent Street Polytechnic in 1947, and at the Royal Academy schools, 1947–52. Worked as a part-time assistant to Henry Moore, 1951–53. Taught part-time at St Martin's School of Art, London, 1953–79. First travelled to the United States in 1959. Taught at Bennington College, Vermont, 1963. Knighted in 1987. Has been the subject of numerous one-man exhibitions. Since 1980 these have included shows in Boston, New York, Berlin, London, Frankfurt, Cologne, Toronto, Saarbrucken, Paris, Edmonton, Manchester, Leeds, Copenhagen, Dusseldorf, Zurich, Baltimore, Stockholm, Malmo, Helsinki, Milan, Chicago, Genoa and Valencia.

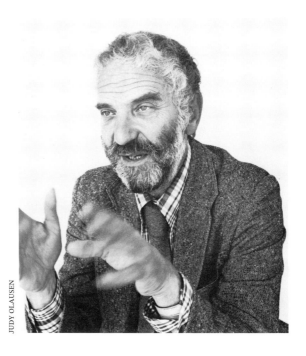

JUDY OLAUSEN

Anthony Caro
Self-Portrait
$13\frac{3}{4} \times 9\frac{3}{4}$in, 35×25cm
Ink on paper

Knoedler Kasmin Gallery, London

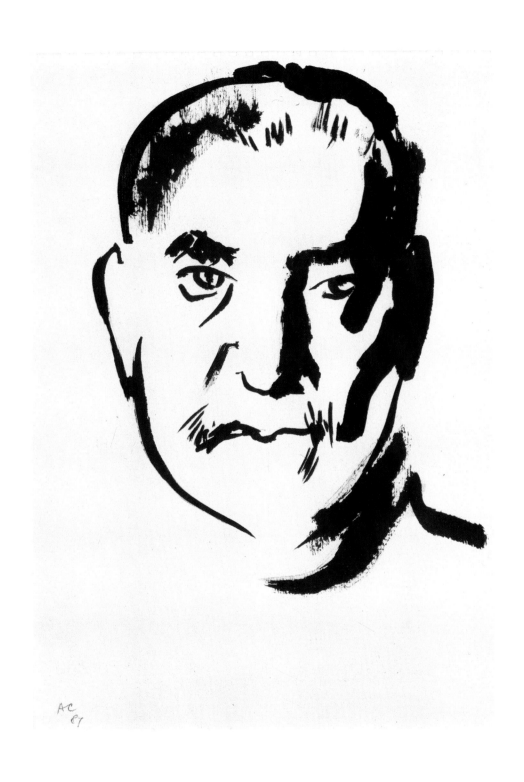

AC
81

ANTHONY GREEN

Born in London, 1939. Studied at the Slade School of Art, 1959–60. Held his first one-man exhibition at the Rowan Gallery, London in 1962, and has continued to have regular exhibitions there. Has also had one-man exhibitions in New York, Stuttgart, Hanover, Rotterdam, Brussels, Tokyo and Washington. He visited the United States in 1967–69 on a Harkness Fellowship. He was elected A.R.A. in 1971 and R.A. in 1977.

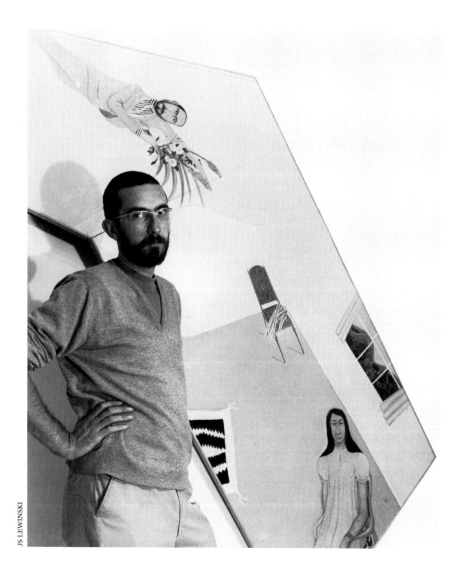

JS LEWINSKI

Anthony Green
**Self-Portrait with
Sears-Roebuck Vest 1969**
$32\frac{1}{2} \times 25\frac{1}{2}$in, 82·5 × 64·8cm
Oil on board

Rowan Gallery, London

144

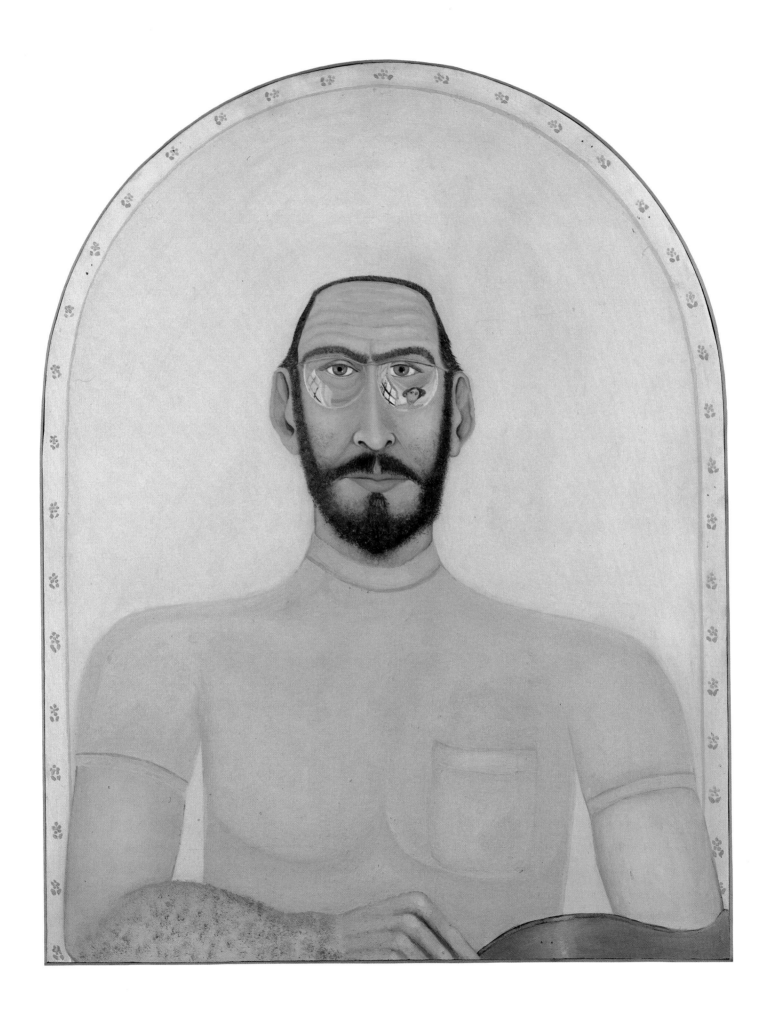

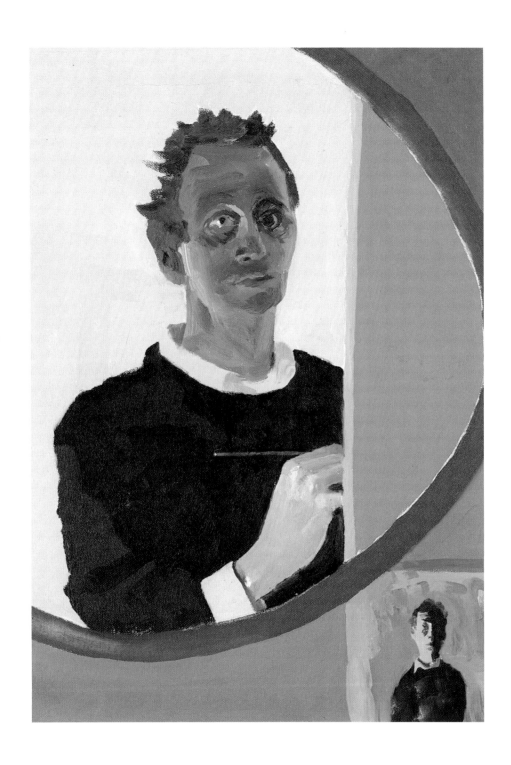

PATRICK PROCKTOR

STEPHEN MOSES

Patrick Procktor
Self-Portrait
$19\frac{1}{2} \times 13\frac{1}{2}$in, 49·5 × 34·2cm
Oil on board

Born in Dublin, 1936, but brought up in London and Brighton. Conscripted into the Royal Navy 1954–56 as a student of Russian. Studied at the Slade School of Art, 1958–62. Visited Italy and Greece in the winter of 1962. Has subsequently travelled to the United States, India, Nepal, Morocco, South Africa, China, Belize, Egypt and Portugal. Held his first one-man exhibition at the Redfern Gallery, London, in 1963. Has since exhibited regularly in London, and has also had one-man shows in New York, Venice and Munich.

Redfern Gallery, London

GRAHAM DEAN

Born in Birkenhead, Merseyside, 1951. Studied at the Laird School of Art, Birkenhead, 1968–70, and at Bristol Polytechnic, 1970–73. Held his first one-man exhibition in Bristol in 1973, and has since held one-man shows in London, Liverpool, Sunderland and Basle. In recent years his range of activity has broadened to include film-making, and he has made four films since 1979.

Nicholas Treadwell Gallery, Bradford

Graham Dean
Self-Portrait
33 × 26¾in, 83·7 × 67·9cm
Watercolour on paper

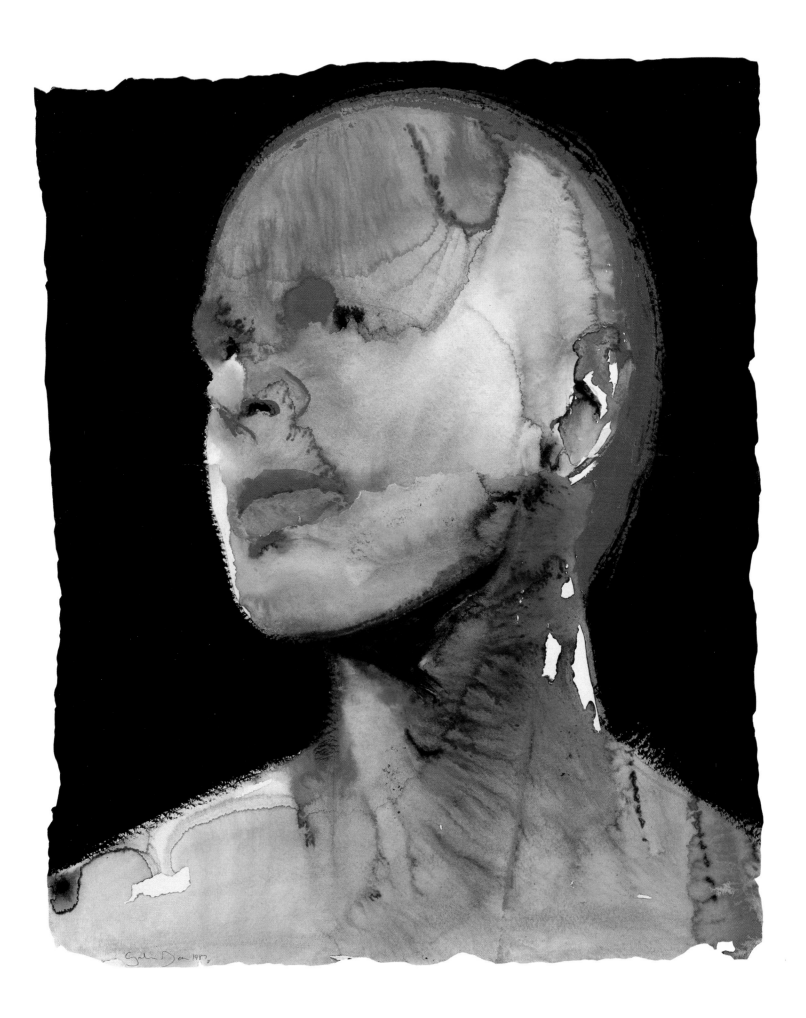

MANDY HAVERS

Born in Portsmouth, 1953. Studied at Portsmouth College of Art and Design, 1971–72; at the Coventry Polytechnic 1972–75; and at the Slade School of Fine Art, 1976–78. From 1980, visiting lecturer at the Slade, at Coventry Polytechnic, and at Trent Polytechnic, Nottingham. She has held a one-woman exhibition at the Arnolfini Gallery, Bristol, which travelled to Liverpool, Glasgow and Dublin, and also one-woman shows in London, Brussels and Birmingham.

Nicholas Treadwell Gallery, Bradford

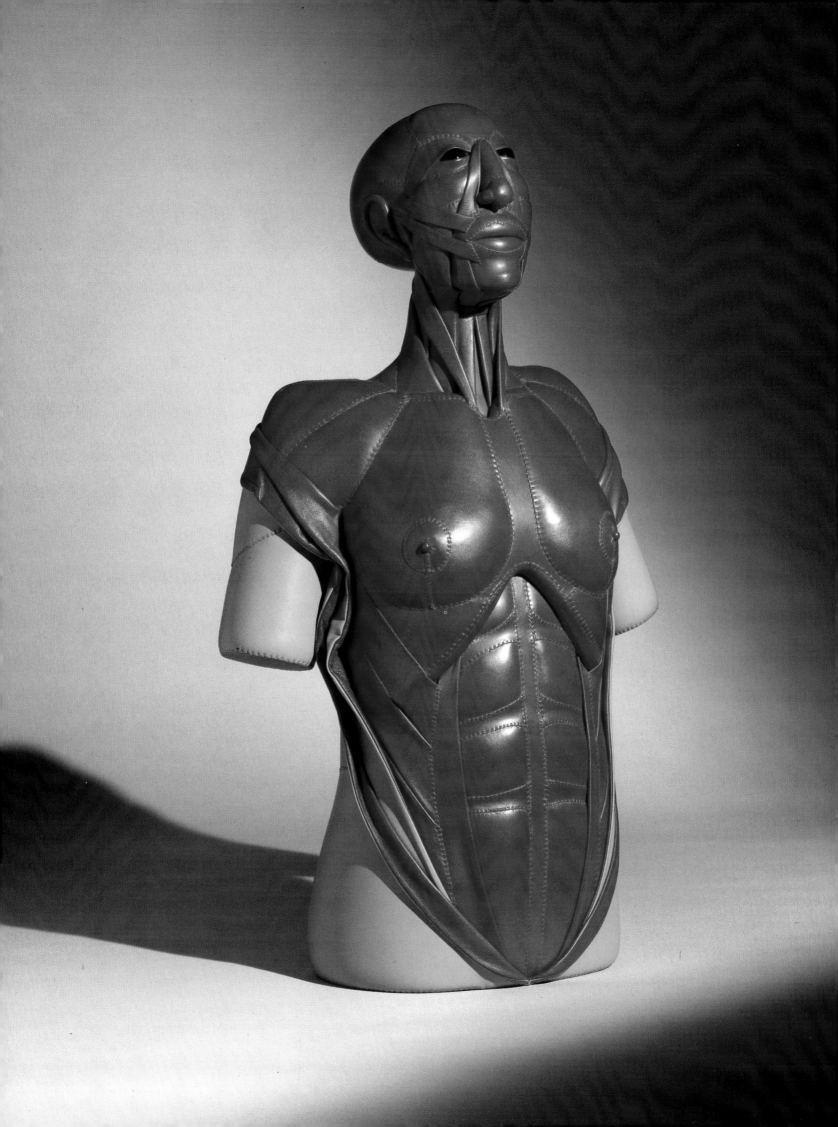

INDEX

5